Remembering
The University
of Florida

Steve Rajtar

TURNER
PUBLISHING COMPANY

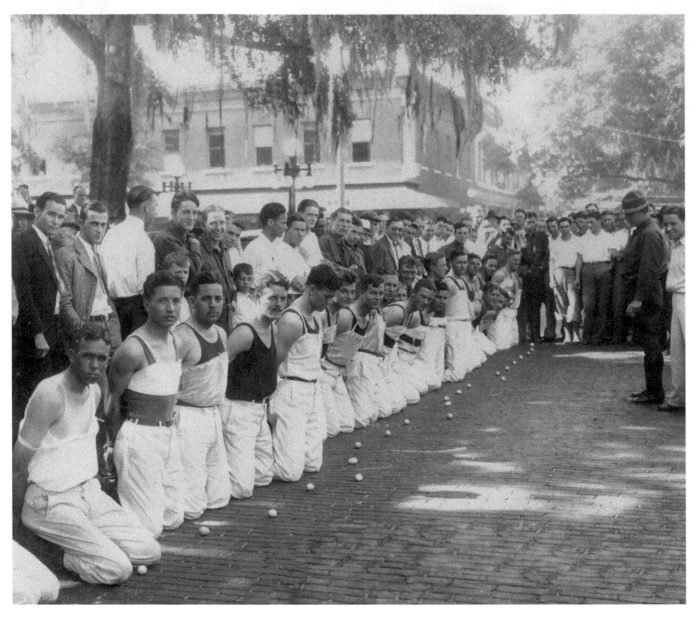

The National Society of Scabbard and Blade was formed in 1904-5 by five senior cadet officers at the University of Wisconsin. From that small group it has grown to more than 100,000 members across the country, serving as an ROTC honor society which prepares students to take a more active part in military affairs. Initiation of new members at the University of Florida is taking place here in 1928.

Remembering
The University of Florida

Turner Publishing Company
4507 Charlotte Avenue • Suite 100
Nashville, Tennessee 37209
(615) 255-2665

Remembering the University of Florida

www.turnerpublishing.com

Library of Congress Control Number: 2010932282

ISBN: 978-1-59652-709-6

Printed in the United States of America

ISBN: 978-1-68336-892-2 (pbk)

CONTENTS

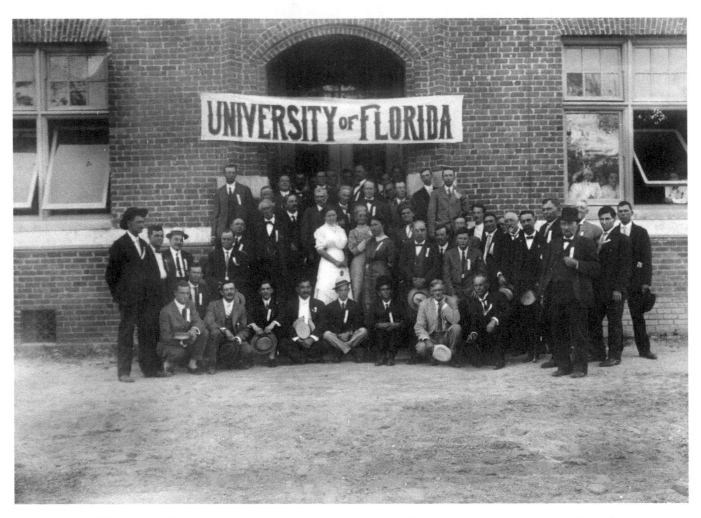

The Agricultural Experiment Station hosted annual seminars to educate working and future farmers in scientific techniques to improve their crops. Citrus seminars began in 1915, a year before this group photograph was taken on campus.

Acknowledgments

This volume, *Remembering the University of Florida,* is the result of the cooperation and efforts of many individuals and organizations. It is with great thanks that we acknowledge the valuable contribution of the following for their generous support:

Florida State Archives
and
University of Florida Archives, Department of Special and Area Studies Collections,
George A. Smathers Libraries, University of Florida

———————

With the exception of touching up imperfections that have accrued with the passage of time and cropping where necessary, no changes have been made. The focus and clarity of many images are limited to the technology and the ability of the photographer at the time they were recorded.

PREFACE

Mention the University of Florida to most people and what will come to mind are national championships in football and basketball. Those knowledgeable in other sports might also recall previous championships in golf, swimming and diving, soccer, and tennis. Professional sports teams feature many former Gator stars on their rosters, and many Olympic athletes competed at the college level wearing the orange and blue of the University of Florida. The school is also known as the birthplace of Gatorade, the carbohydrate-electrolyte beverage developed there in the mid-1960s to give the school's football players relief from heat-related illnesses.

With colleges and universities being strongly identified with sports programs, it's easy to forget that every school has a history which, before television, relegated sports to little more than just another extracurricular activity for students. It was the academic program which defined the school and attracted students.

Unlike many schools which were founded with a single beginning date, the University of Florida instead resulted from a consolidation of several smaller institutions. One began in Ocala, shut down during the Civil War, and then moved to Gainesville to combine with another with a strong military program. Another came from Bartow, where it prepared young men for careers in military service. Another had been located in St. Petersburg and educated those desiring to become teachers. Yet another was located in Lake City and focused on agriculture. The state consolidated these schools to form the University of Florida, and selected Gainesville as its home.

The university, with its military and agricultural roots, has grown to be one of the largest educational institutions in the country, and has an international student population. There are alumni alive today who can recall the days when there were hundreds, not tens of thousands, of students and none were members of racial minorities. Until after World War II, except for a very small number of women granted admission, all of the students were male. Many of the old buildings remain on the campus, but the appearance of the students who pass between them is very different from those of decades ago.

The University of Florida often occupies the spotlight when it comes to sports prominence, whether it involves a trio of Heisman Trophy quarterbacks or swimmers winning Olympic medals in Beijing, but there is more to the school than mere athletics. The university is a world leader in numerous areas of engineering and science. It remains an important research institution for agriculture, and an essential resource for those in Florida who make their living from the land. Its medical school and research facilities enjoy an international reputation in many medical disciples.

On the following pages are images dating from the early days, when those schools which would later compose UF were located on several campuses, before moving to the large tract along Gainesville's University Avenue. The photos capture the look and feel of the buildings and areas in between, and the students who came to Gainesville to pursue a quality education. They depict the early military theme, which reappeared during World Wars I and II when the campus was used for training soldiers. They also evidence the strong early focus on agriculture, which is still present on campus but is often overshadowed in the news by the school's accomplishments in medicine, technology, and sports. The images are arranged chronologically, bringing the viewer from the school's origins all the way up to more recent times.

—Steve Rajtar

James M. Jackson, Jr., was a cadet at the East Florida Seminary in the 1870s, not long after the school moved north from Ocala to merge with the Gainesville Academy. Jackson in 1896 became Miami's first resident physician.

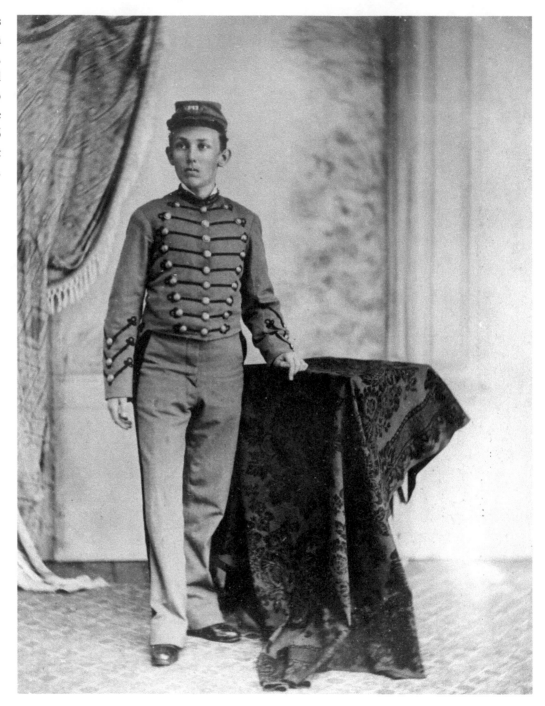

Parent Institutions

(1887–1905)

Edmund Sydney Williams of Rockledge posed for his East Florida Seminary portrait around 1887 at the age of 16. In its early years, the student population included children as young as four and as old as twenty.

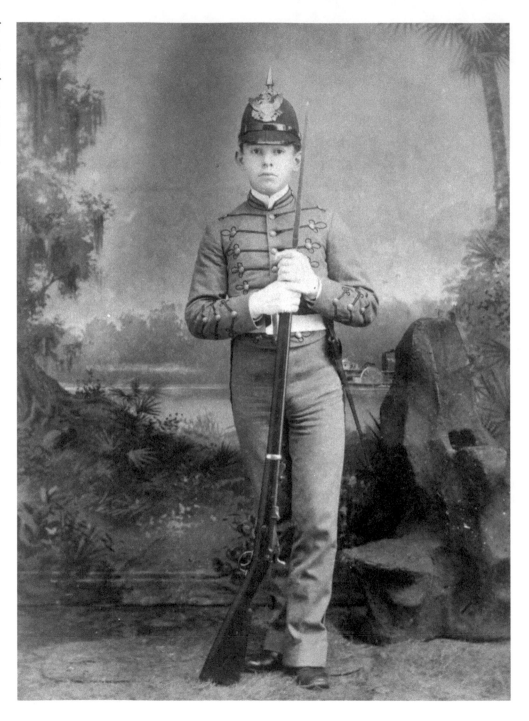

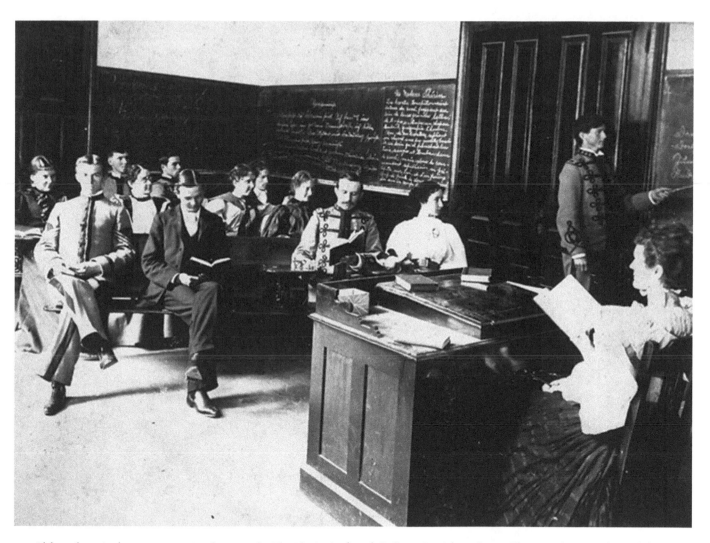

Although agriculture was a major focus at the Florida Agricultural College, President Oscar Clute implemented a widely varied curriculum. Courses at FAC included ethics, logic, mathematics, manual training, science, and modern languages such as German, which is being taught in this class photographed in 1893.

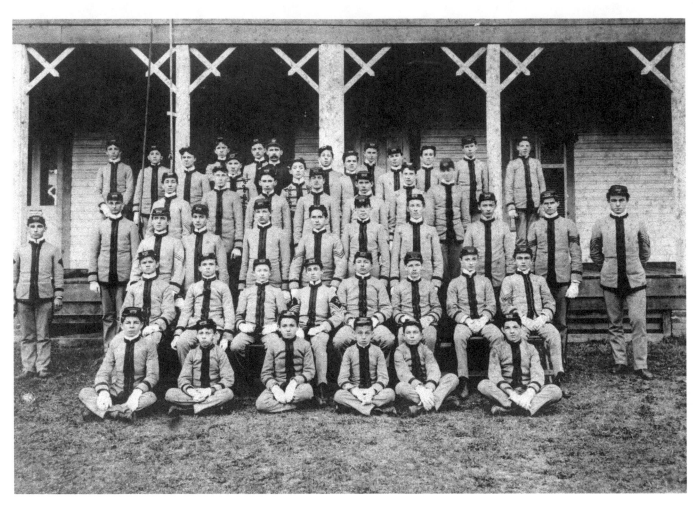

A group of cadets pose for the photographer in 1901 on the steps of the men's dormitory. Ten years later, the large wooden building burned down and was not rebuilt. The site, including the adjacent parade ground, was turned into a Gainesville city park.

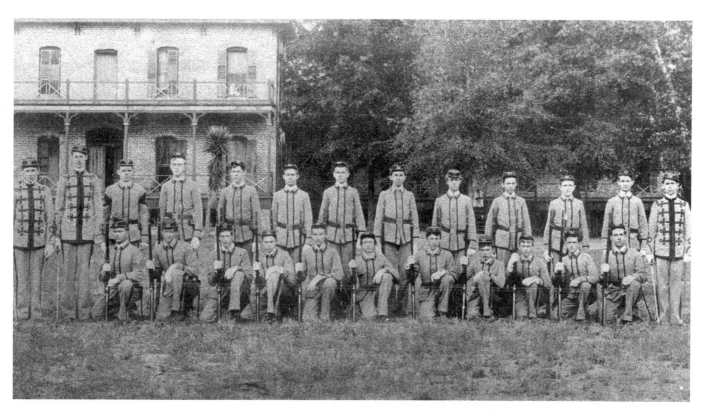

A group of East Florida Seminary cadets gather on the school's parade ground, now the municipal Roper Park, shortly after the turn of the century. In addition to drilling as a military unit, the male cadets marched in formation as they moved from class to class throughout the day.

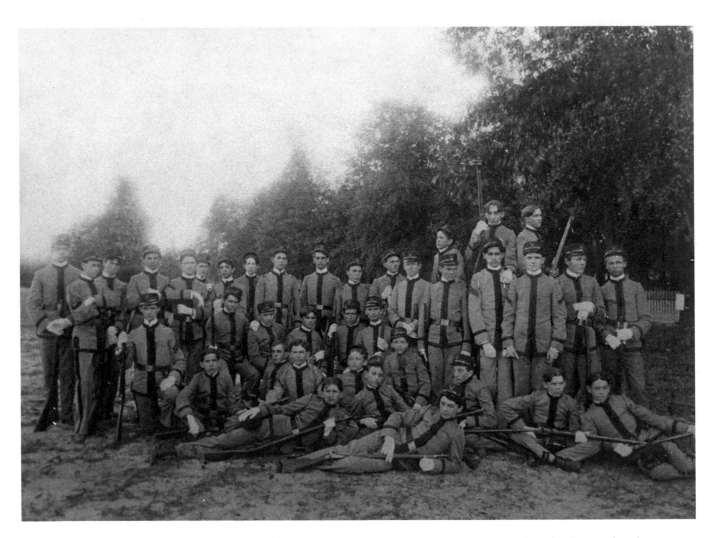

Shown here are cadets of the Florida Agricultural College in Lake City. In 1887, three years after the school opened, military instruction was added to the curriculum. By 1892, the student population had grown to 85 (all male), 75 of whom were actively involved in the cadet program.

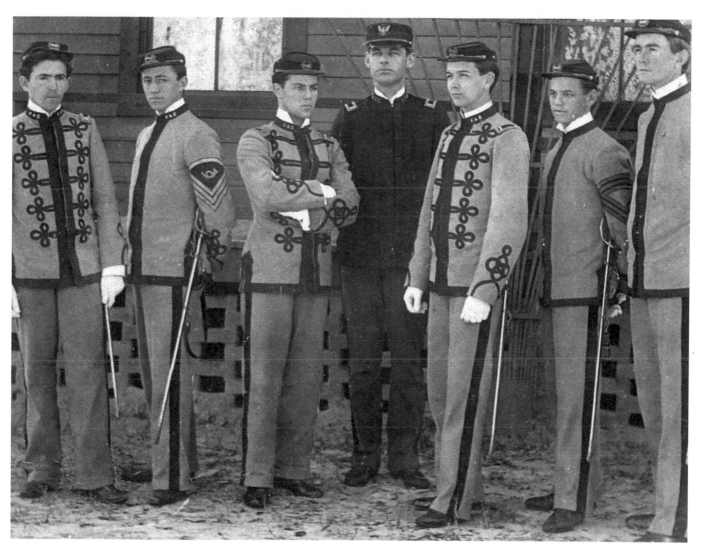

These East Florida Seminary cadets and many others attended classes in Epworth Hall, a two-story brick building located on the west side of the parade grounds. It served as the initial Gainesville campus of the University of Florida. Since 1911 it has been part of the First Methodist Church.

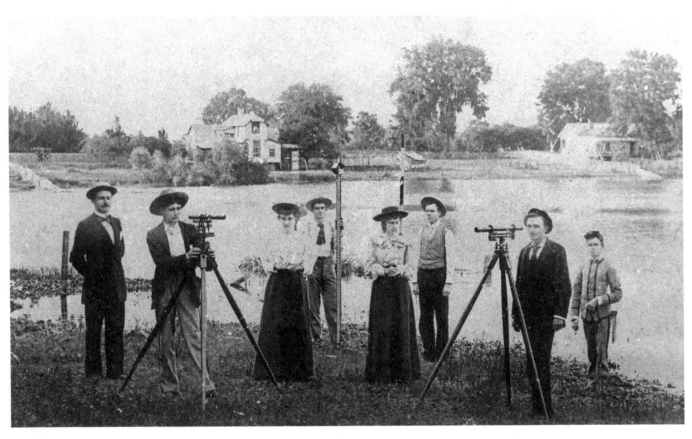

Professor Harry P. Baya (at left) conducts field exercises with his surveying students about 1896. By that time, the FAC student body had been expanded to include female students. Jessie Bending, third from left, later married the professor.

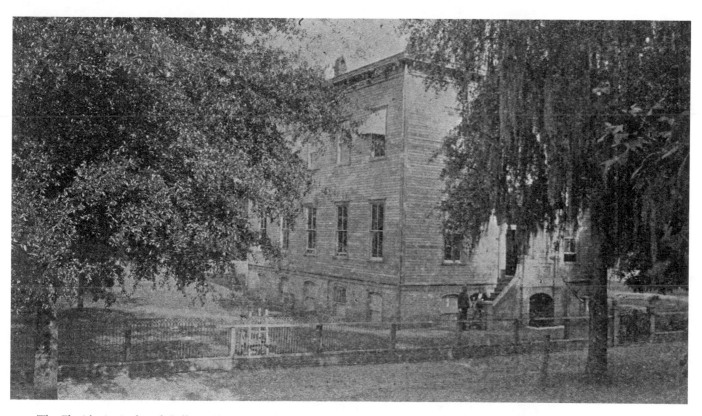

The Florida Agricultural College Chemical Laboratory looked like this in 1897, when faculty and staff members were actively involved both in the agricultural and general education activities of the school, and the separate but related research and experimentation projects of the Agricultural Experiment Station.

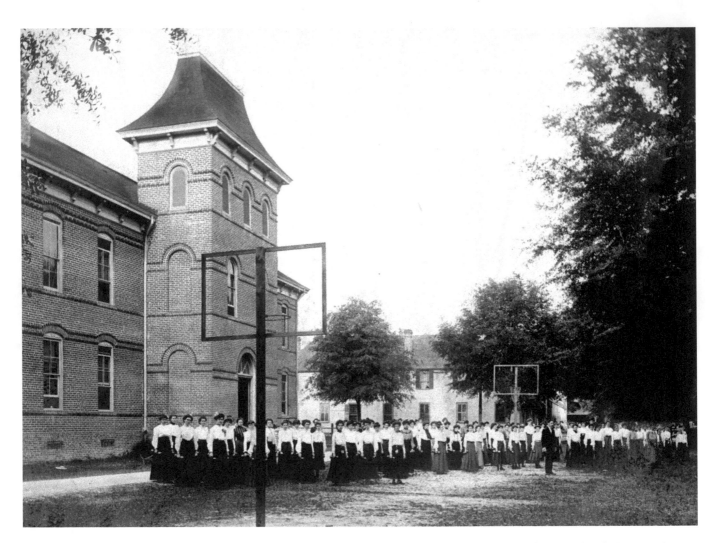

In 1898, the lot where these female students stood, just south of the three-story entrance tower of the East Florida Seminary's Epworth Hall, served as a basketball court. Today, this lot is occupied by a large brick structure, part of the First Methodist Church. The main entrance to Epworth Hall is no longer through the tower.

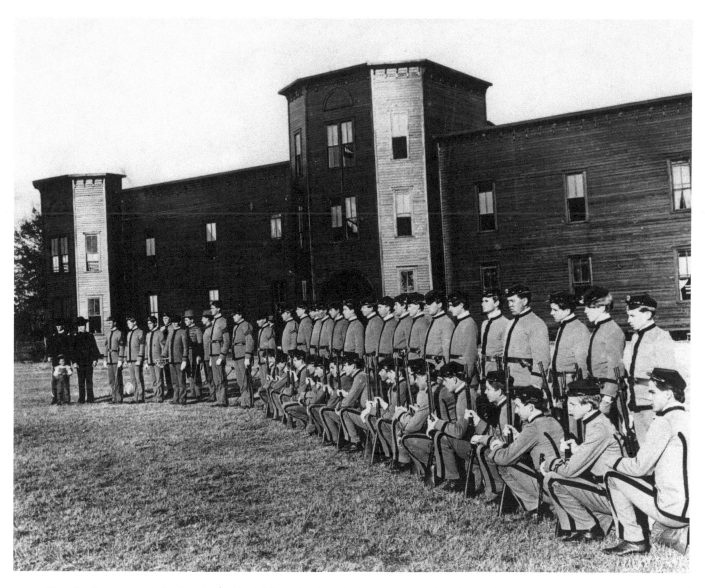

Evander Law opened the South Florida Military Institute in Bartow in 1894 and served as its superintendent. It started with private funding, opened for classes in September 1895, and that same year began receiving financial support from the state. Along with the state money came a state-appointed Board of Trustees, who clashed with Law, resulting in his resignation in 1903.

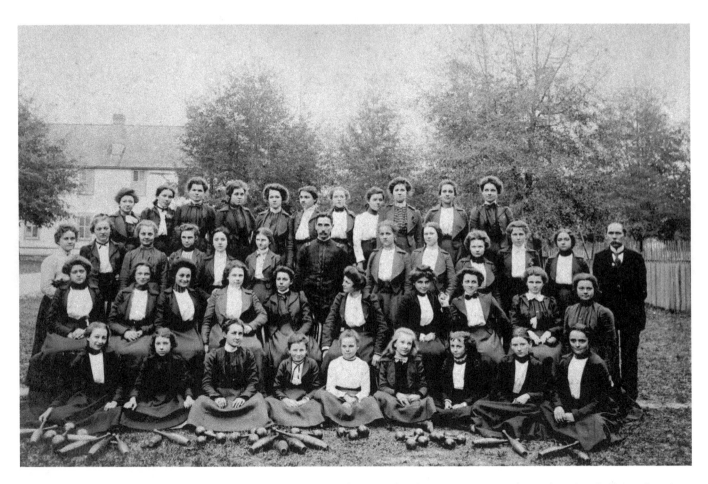

Unlike the university into which it was merged five years later, the East Florida Seminary was truly coeducational. Shown here is the class of 1899-1900. Curiously, despite their formal attire, the students pose with a collection of Indian clubs, used in physical education classes.

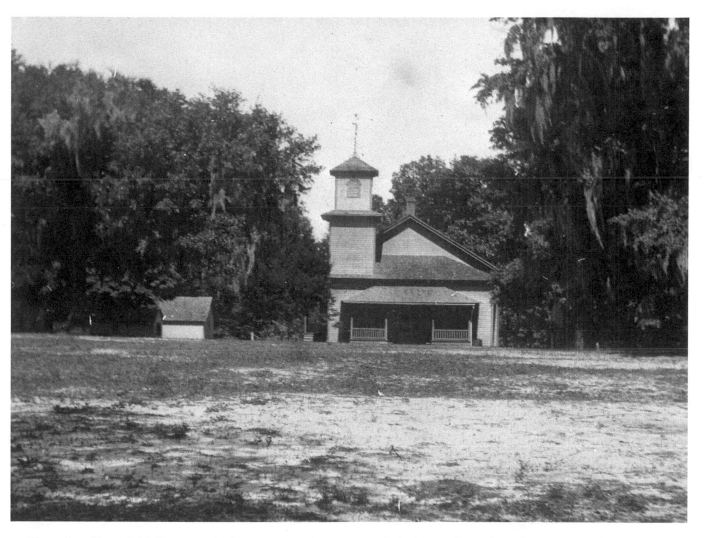

The college library initially consisted of up to 2,000 volumes, most of which were donated. With government funding the FAC collection grew but was managed by part-time librarians, the first one a student. By 1894, professors had begun to assume librarian responsibilities.

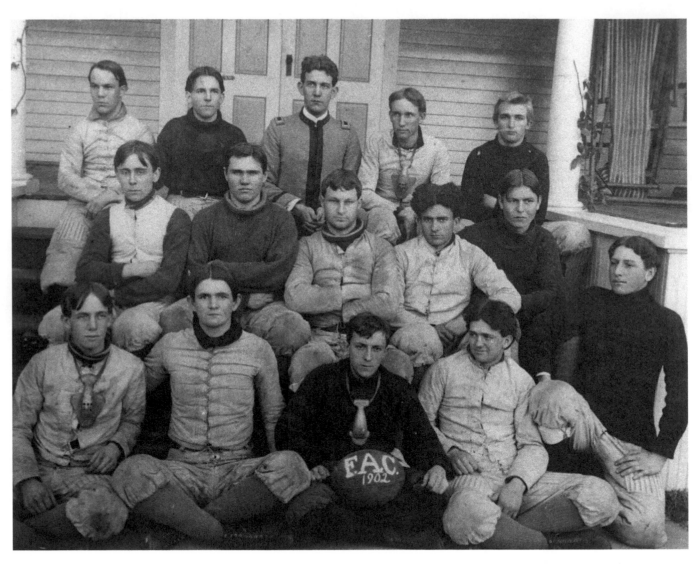

In 1901, this team from the Florida Agricultural College wore the school colors of blue and white and played the school's first football game against Stetson University. FAC lost by a score of 6-0 and also lost road games to Alabama, Georgia, and Georgia Tech. In 1902, it split a pair of games with a school now known as Florida State University.

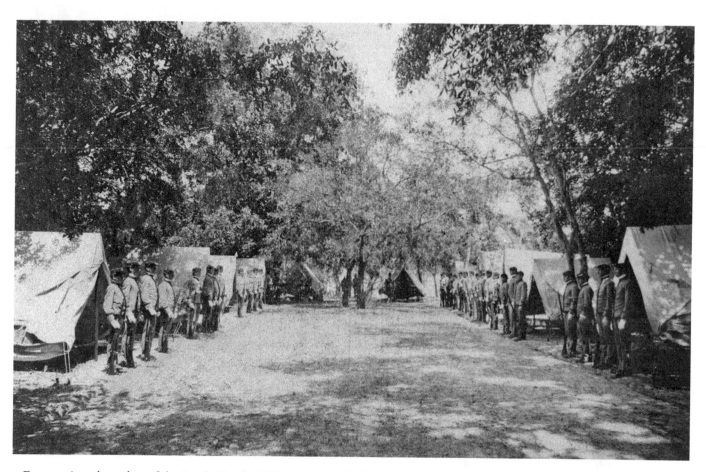

Every spring, the cadets of the South Florida Military Institute held a four-day encampment. Shown here are their tents set up in 1905 at a location near Tampa. At the 1904 encampment, the cadets won a $50 prize from the Tampa Festival Association as the best-drilled cadet company in the state. That they were the only team in the competition gave them a huge advantage.

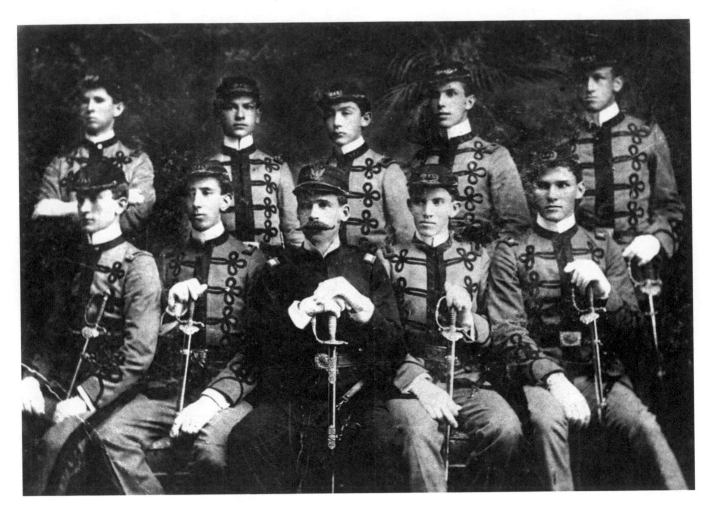

The Gainesville Academy, both before and after it merged with the East Florida Seminary, had a student body which included both males and females. The males were required to wear the uniforms of military cadets and were roused each morning with the call of a bugle.

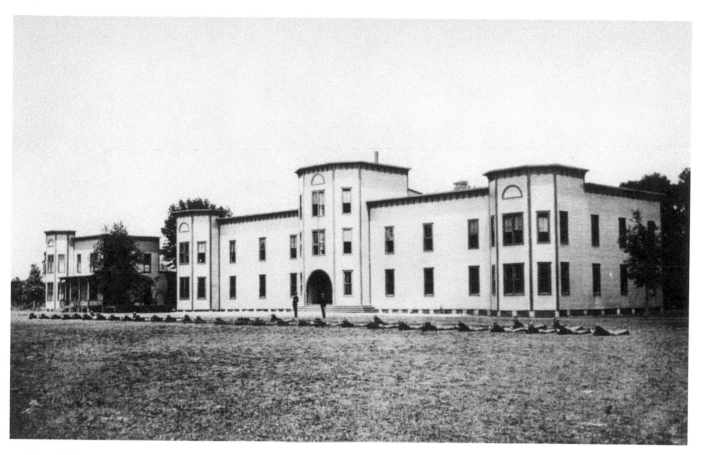

Two of the main buildings of the South Florida Military Institute are shown here in 1904, on a 13-acre campus a little south of downtown Bartow. To the left is the faculty residence hall, and the large building on the right housed the cadets. In the barracks at rear was a walkway along the second floor, and from there the cadets marched downstairs and through the front archway to the parade ground at front.

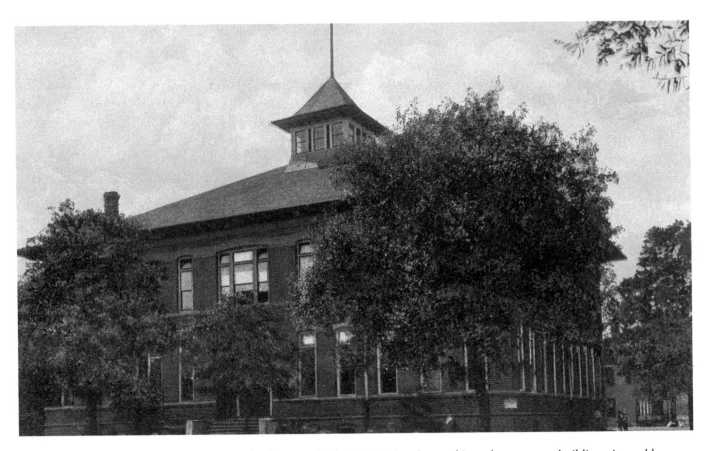

The St. Petersburg Normal and Industrial School was established in 1893 and moved into the two-story building pictured here in 1902. Its normal school educated those going on to be teachers, and its library begun in 1895 was added to the University of Florida library. Much of the rest of the school equipment was transferred to the county's public school system.

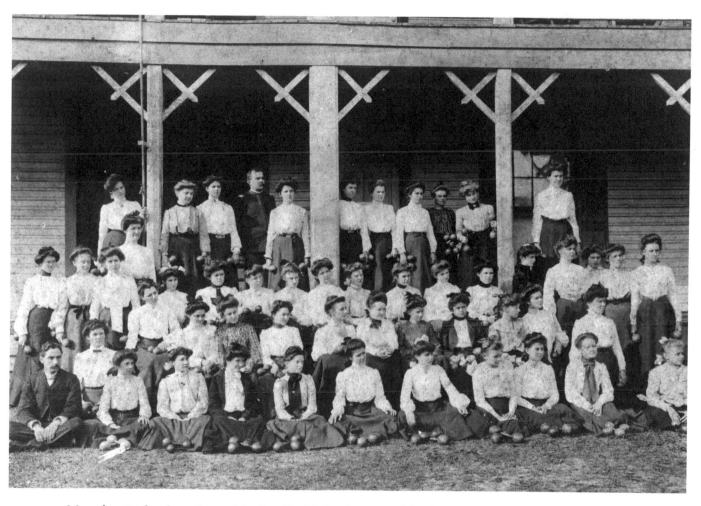

More than 50 female students of the East Florida Seminary posed for this group portrait in 1903. Along with them was Colonel J. M. Guilliams, who had taken over as the superintendent of the school in 1902.

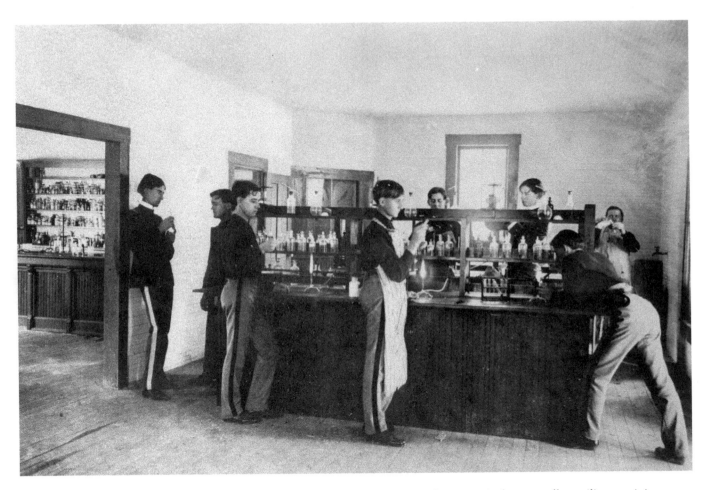

When Evander Law established his military institute, he insisted on a strong academic curriculum as well as military training. Law had previously taught at King's Mountain Military Academy and helped to found the Tuskegee Military Institute. His chief interests were history and biography, but he made sure his school had a strong science program. Inorganic and organic chemistry were taught in the third and fourth years.

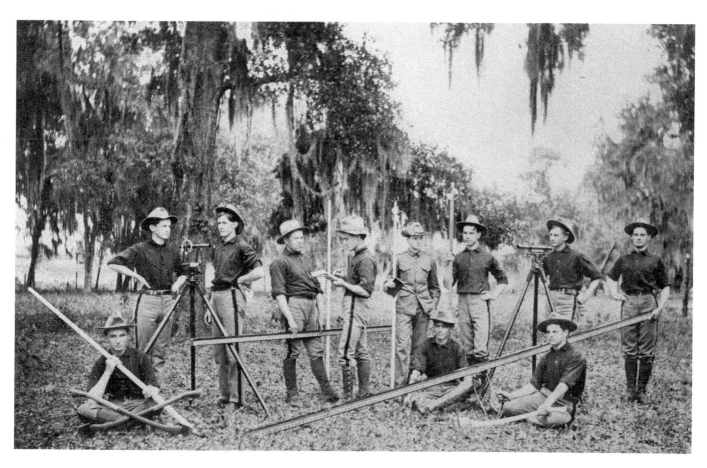

It is no surprise that the South Florida Military Institute taught surveying, since founder Evander Law had himself been a surveyor for a time. After the Civil War he surveyed railroad rights-of-ways, and before 1873 he was the president of the King's Mountain Railway. Surveying was taught in the third year of the five-year program.

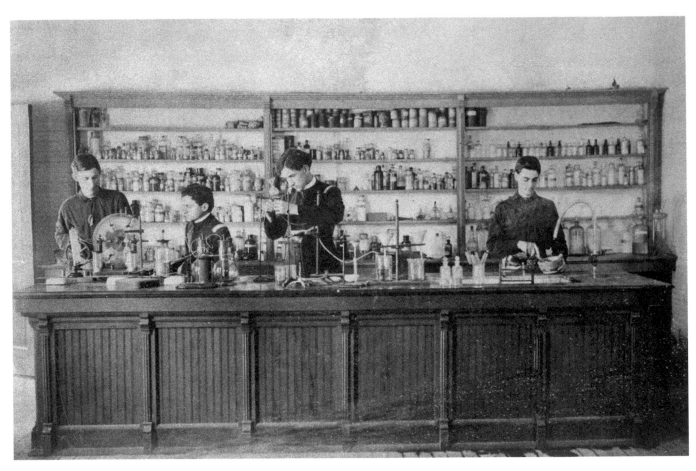

Shown here is the lecture room inside the chemical laboratory of the South Florida Military Institute. The original image was first published in 1904 in *Taps*, the yearbook for the school. Students at the school had to be at least 15 years old and at least 5 feet tall.

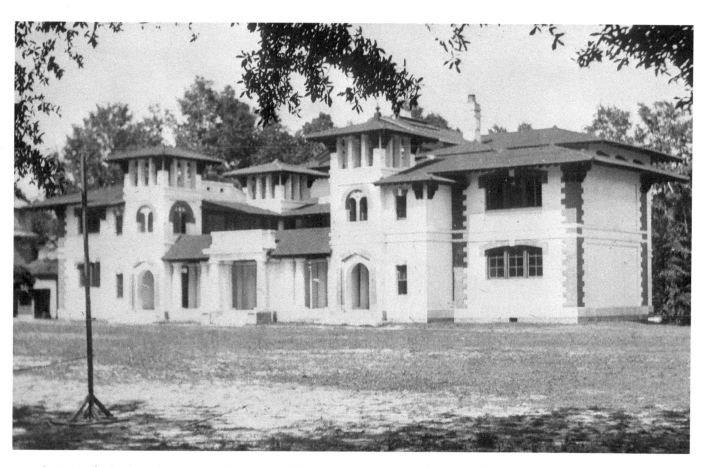

In 1905, the FAC mathematics professor was W. S. Cawthon, who doubled as the college's librarian. He was also in charge of packing up everything and moving it to Gainesville where the Florida Agricultural College (by that time renamed the University of Florida) would become the College of Agriculture in the newly consolidated University of Florida.

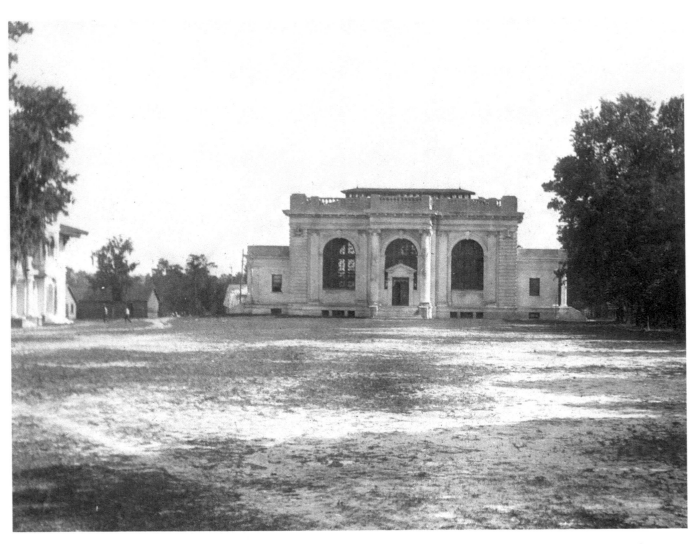

A strong emphasis was placed on physical education at the Lake City campus, where this attractive gymnasium was built for indoor sports and exercises. Named for railroad magnate Henry Flagler, the building was occupied by the Red Cross after the school departed for Gainesville.

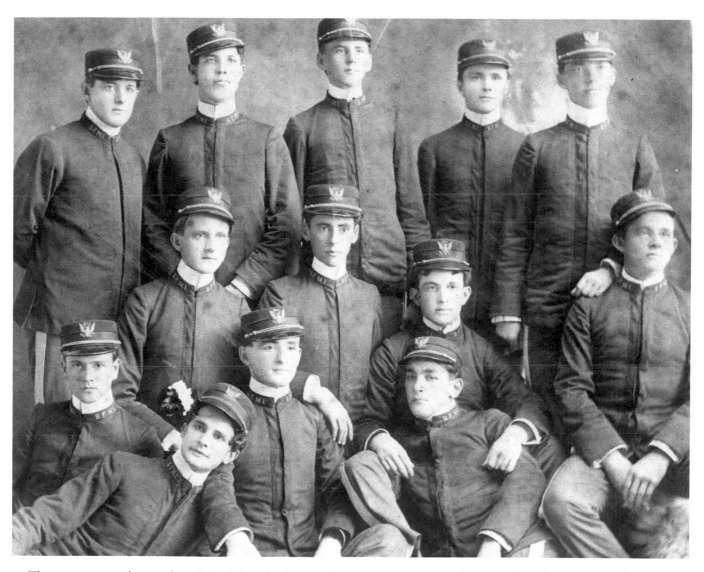

The most noteworthy member of this SFMI class is the cadet standing to the right. He was Robert Andrew Gray, who served in the army in World War I and for six decades held various positions in state government. In 1930, he was appointed secretary of state and continued in that office until he stepped down in 1961.

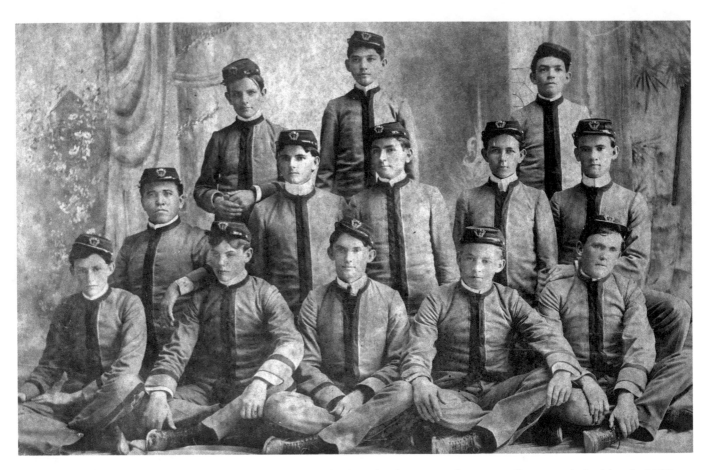

Each state senator was permitted by law to nominate one cadet from his district, resulting in 32 five-year scholarships. In 1897, the law was changed to include counties rather than senatorial districts, increasing the number of free educations to 45. Those who paid an annual $200 tuition brought the annual average to 55 students, including some who lived with their families in Bartow and attended day classes.

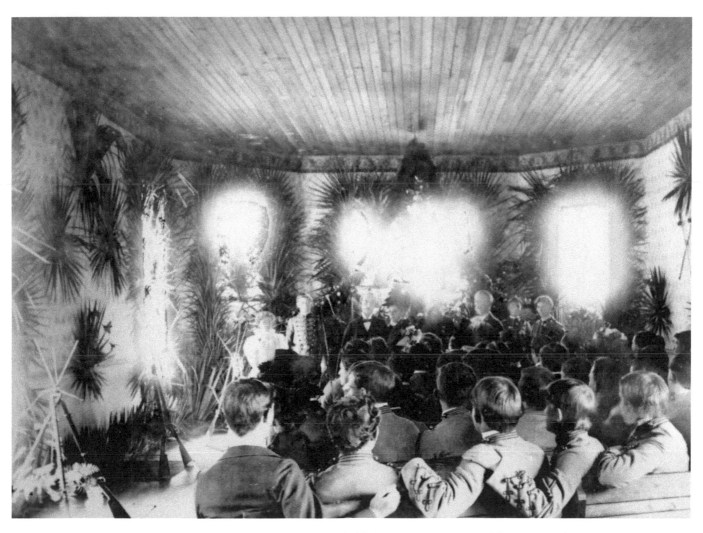

This ceremony at the South Florida Military Institute was held shortly after the turn of the century. Among cadet graduation ceremonies of the day, the ceremony of 1904 is noteworthy: Following Evander Law's resignation as superintendent, all but three of the seniors did the same. They did not want diplomas unless the papers bore Law's signature. Those who left school were in 1927 granted degrees by the University of Florida.

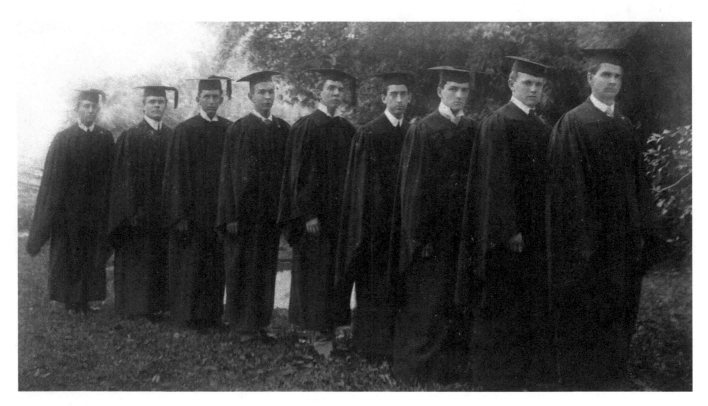

While plans were being formulated for the move to Gainesville in 1906, classes continued at the University of Florida on its campus in Lake City. Its last school year included a graduation ceremony where these nine young men became UF alumni.

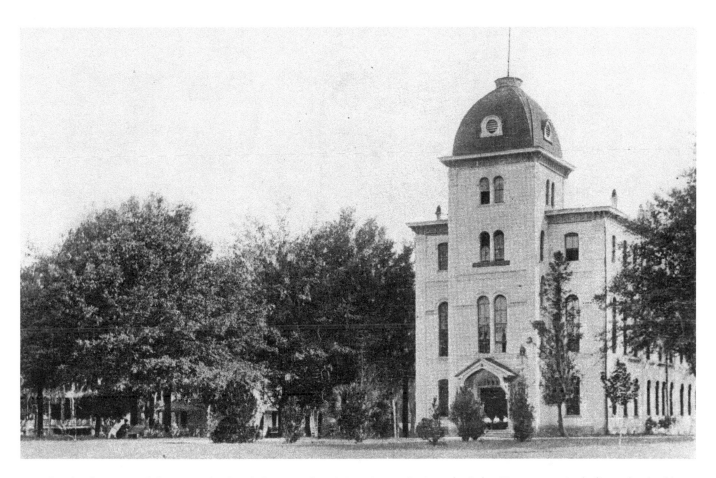

After the departure of the state school and the Agricultural Experiment Station, the Lake City campus including what had been Chapel Hall became the home of Columbia College, a Baptist school. By the end of the 1910s, the buildings were dilapidated and in 1920 the land was sold to the federal government. The site is now home to a Veterans Administration medical center.

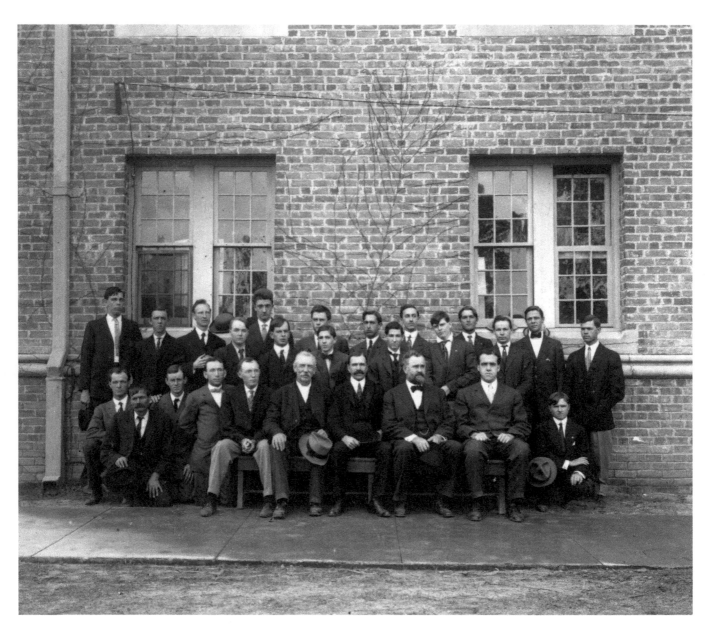

In addition to college-level courses in modern agricultural methods, students with similar interests began forming clubs not long after the move to Gainesville, to gain access to additional vocational and social opportunities. The school's first Agricultural Club posed for this portrait in January 1910.

Early Years in Gainesville

(1906–1919)

This faculty group portraits includes Albert A. Murphree (seated, second from left), the university president beginning in 1909. To his right is James M. Farr, who served as vice-president. Upon Murphree's death in 1927, Farr, formerly head of the Department of English, assumed leadership of the school.

The Agricultural Experiment Station was in some ways independent of the university, but it also shared facilities and personnel. Many of the individuals in this 1910 staff portrait also taught regular college courses as faculty of the College of Agriculture.

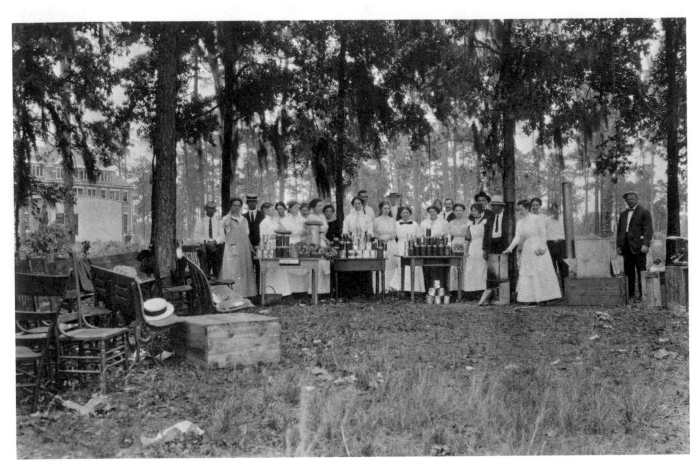

Although university enrollment was limited to males, women could join Tomato Clubs formed under the auspices of the Agricultural Experiment Station. Show here is demonstration put on by one such Tomato Club in January 1912, displaying proper techniques for canning and preserving food.

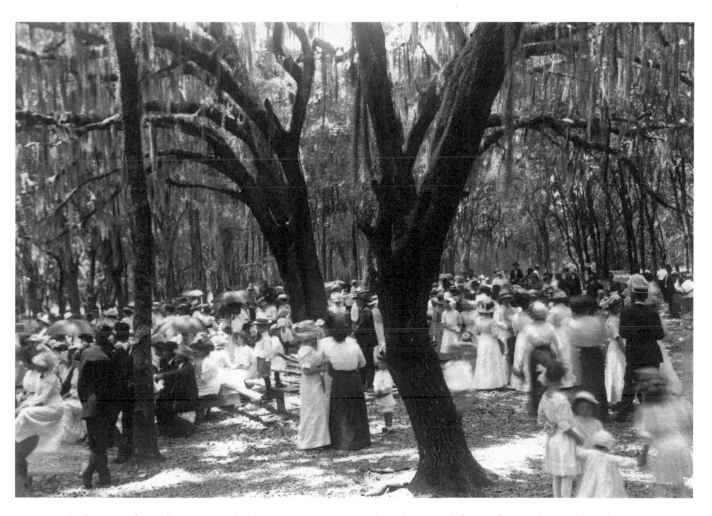

Gatherings of area farmers included instruction on campus, but also provided time for socializing. Show here in 1912 are attendees for the Farmers Institute relaxing at a picnic held at Coots Pond in Levy County.

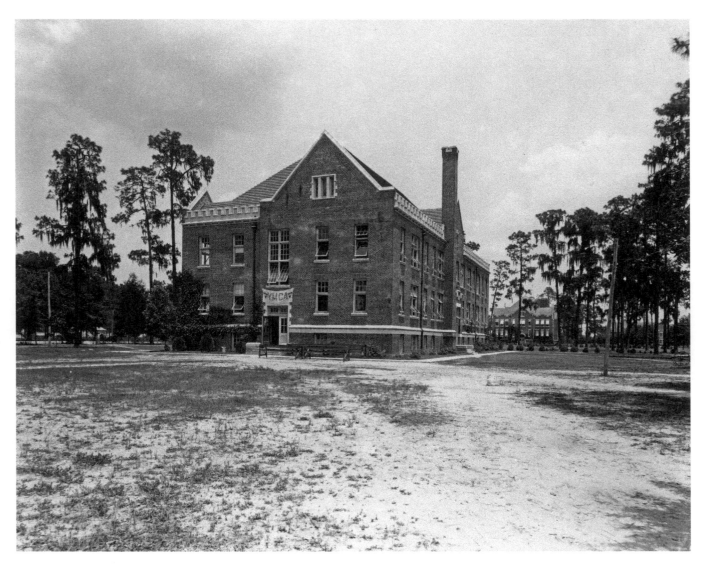

Until a true student union building was constructed in the 1930s, the student population of the University of Florida had social and support facilities spread out among several campus buildings, including the dormitories. One popular organization, the Young Men's Christian Association, was located in this building for a time. A permanent home for the YMCA was later established in the student union.

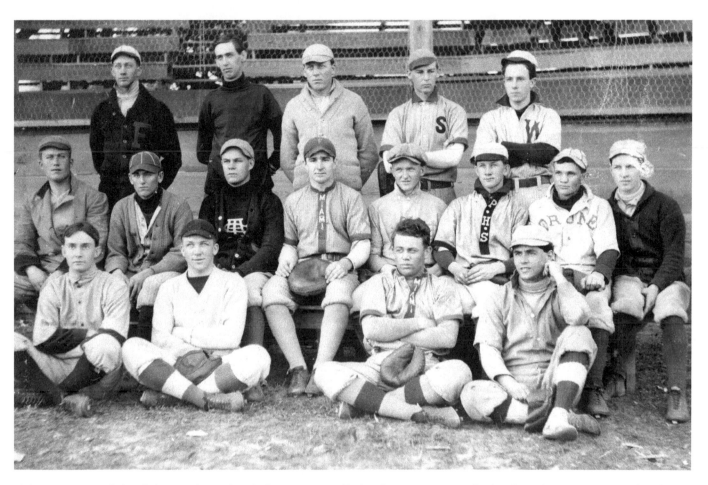

The University of Florida began playing baseball on an intercollegiate basis in 1912, under head coaches H. D. McLeod and R. P. Hoffman, who lasted one season each and compiled a combined record of 20-13-3. Shown here is the team of 1914, the first year of the three-year tenure of Coach Pat Flaherty, whose teams scored 15 wins, 29 losses, and 1 tie.

Roy Van Camp poses in his University of Florida football uniform in 1916. An engineering student, he also played on the Gators baseball team.

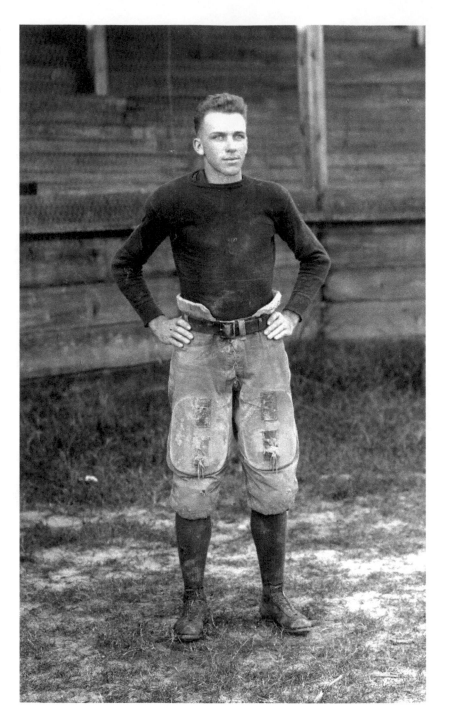

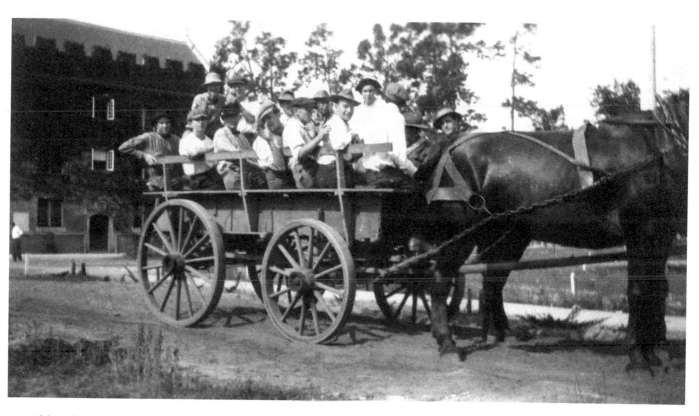

Although the automobile and motorcycle had been invented, there weren't many on campus in 1915. University students who weren't walking were more likely to be found riding horse-drawn vehicles.

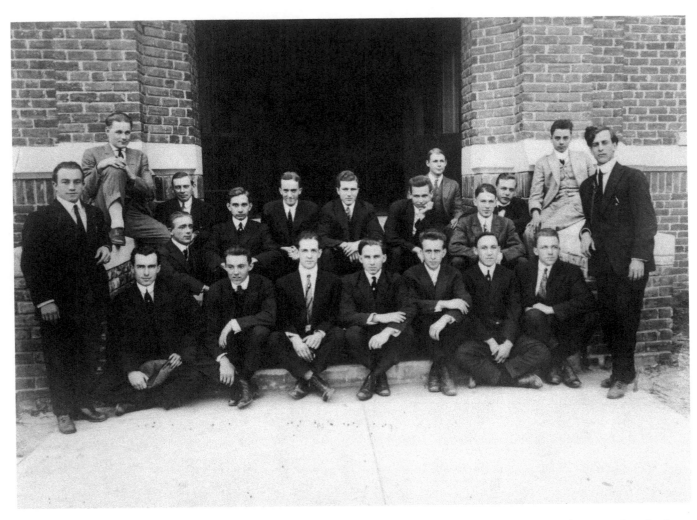

In 1909, the University of Florida was composed of four colleges—Law, Arts and Sciences, Agriculture, and Engineering. Students of the latter pose for this group portrait in 1916.

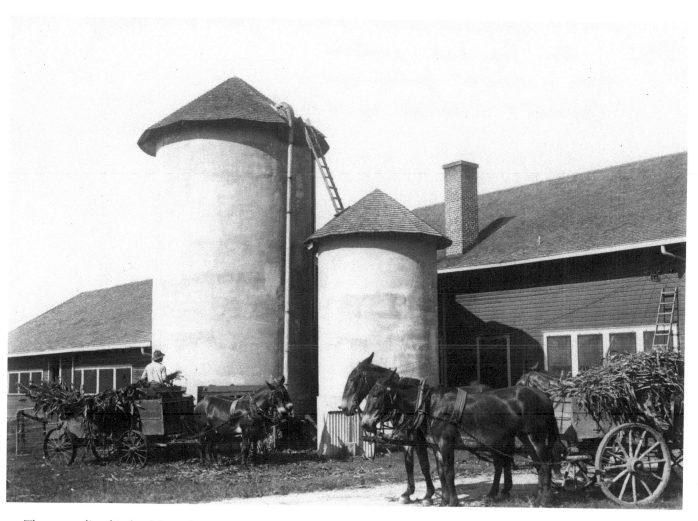

The two earliest kinds of 4-H Clubs attending functions at the University of Florida were the girls' Tomato Clubs and the boys' Corn Clubs. Classes were usually conducted by county extension agents in the public schools, following which students came to university-operated farms like this one to gain hands-on experience. In this image, wagons loaded with silage corn are parked near a pair of silos.

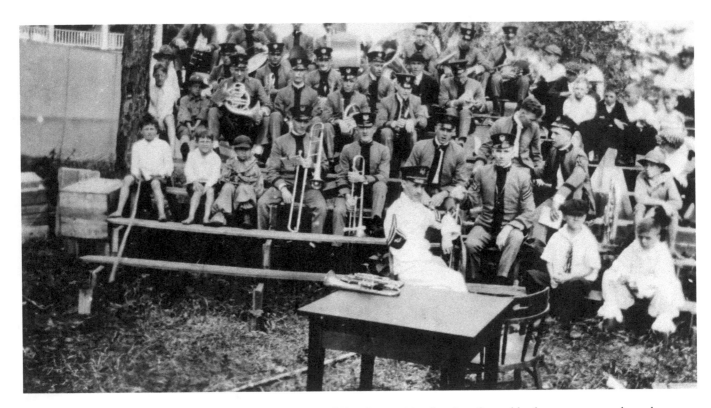

Before enlisting for service in World War I, the University of Florida marching band performed both on campus and at other locations around the state. Here they are shown performing at a celebration in Fort Myers.

STILL STRONGLY AGRICULTURAL

(1920–1945)

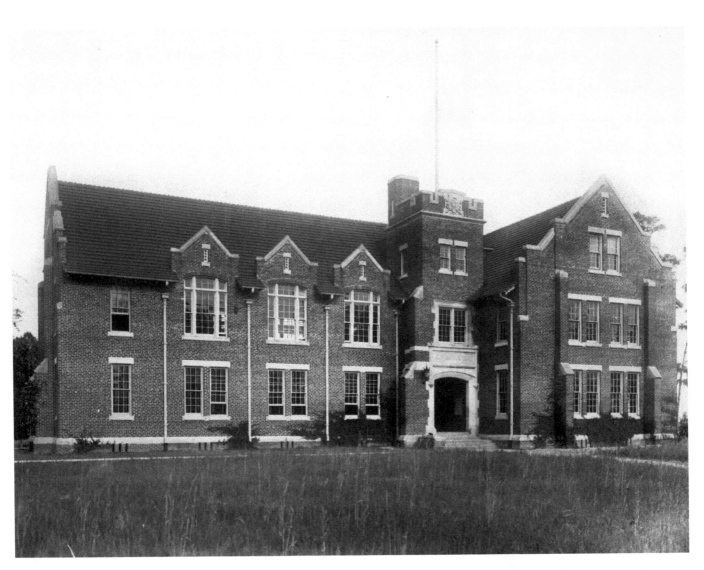

One of the early campus buildings was Bryan Hall, complete in 1914 in the Collegiate Gothic style of William Edwards. From its opening until 1969, it was the home of the College of Law. It was named for the first chairman of the Board of Control, U.S. senator Nathan P. Bryan, who was involved in choosing Gainesville as the home of the university and in establishing a law school.

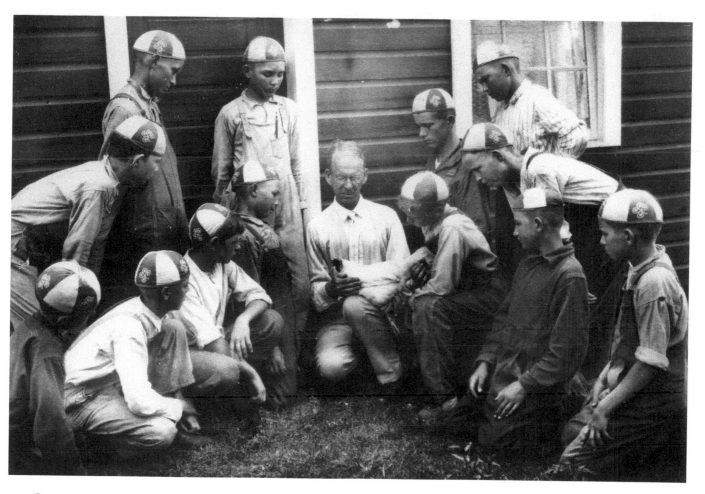

County extension agents based at the University of Florida were able to assist not only established farmers but also 4-H Clubs, which had begun forming in northern Florida in 1909. The agents met with the clubs to provide "hands-on" instruction as well as lectures on successful agricultural methods.

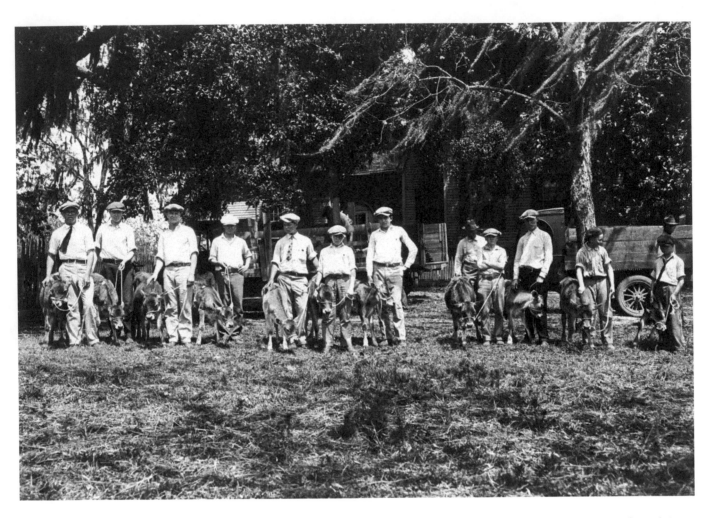

The Agricultural Experiment Station and the University of Florida College of Agriculture provided instruction to rural youth in a pair of programs. Beginning in 1910, "short courses" were held for groups temporarily residing on campus, and representatives were sent to establish 4-H Clubs such as this one participating in calf judging.

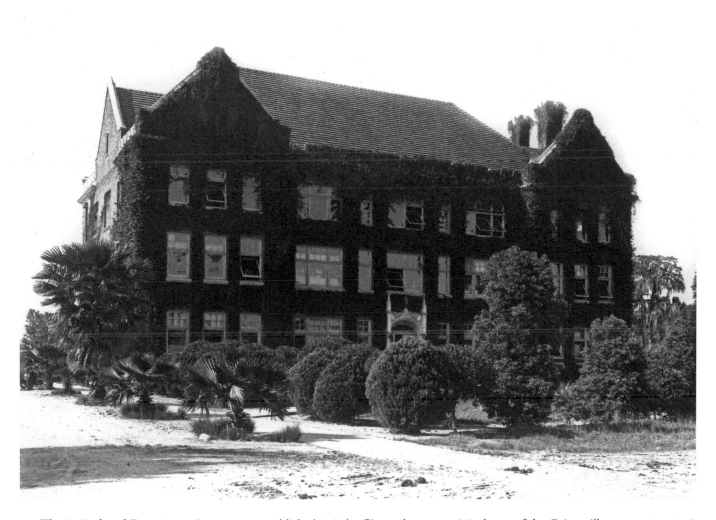

The Agricultural Experiment Stations was established in Lake City and was an original part of the Gainesville campus in 1906. Experiments were conducted in Thomas Hall until the completion of this structure in 1910. The new home of the station was designed by William Edwards and still stands along Buckman Drive.

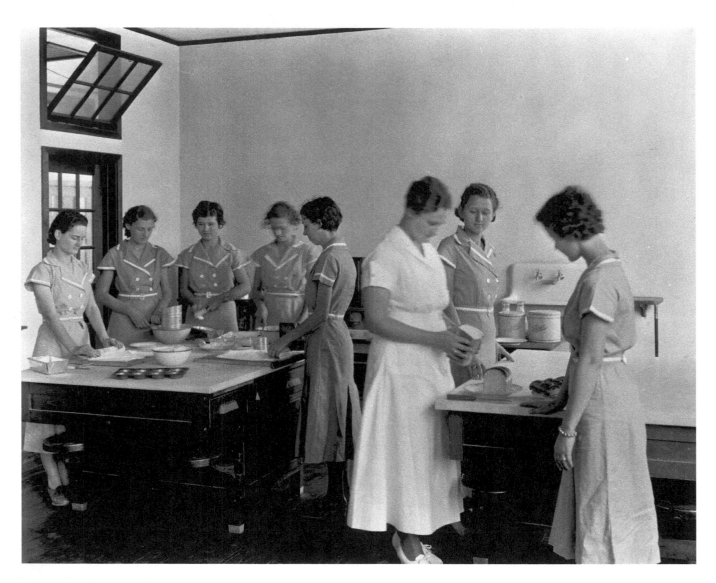

The two leading state schools, the University of Florida and the Florida State College for Women, were the headquarters of the state extension service. The UF campus was headquarters for extension agents who focused on teaching men good agricultural techniques, and the FSCW stationed female agents, who traveled the state teaching women domestic skills like the baking in progress here.

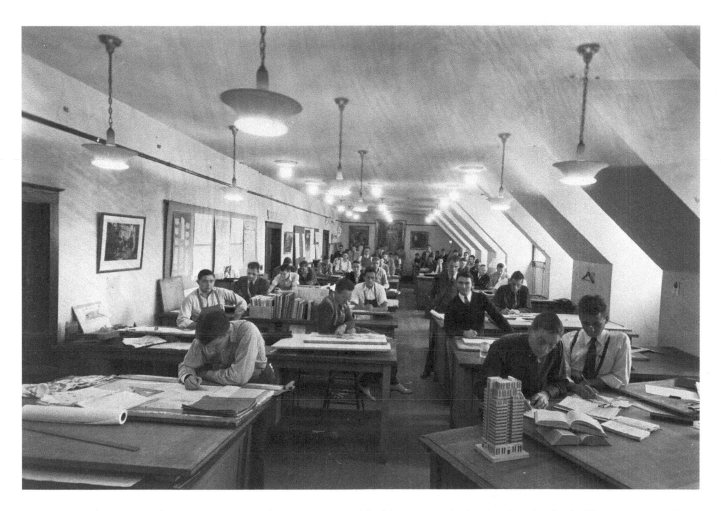

During the 1920s and 1930s, students in the Department of Architecture worked on projects in the drafting room upstairs in Peabody Hall. The model of the skyscraper in the foreground does not resemble any building constructed on campus or in Gainesville, but the clothing these students wear—some of them shown here in ties and coats—was seen everywhere.

With the Student Union to the right behind the trees, this is an early look at a portion of the campus green, later known as the Plaza of the Americas. It took on a new look in 1925 when the university had the area remodeled by one of America's best-known landscape architects, Frederick Law Olmsted, Jr., who work included Bok Tower Gardens in Lake Wales, Florida. (Olmsted's father had designed New York City's Central Park and other famous retreats in the nineteenth century.)

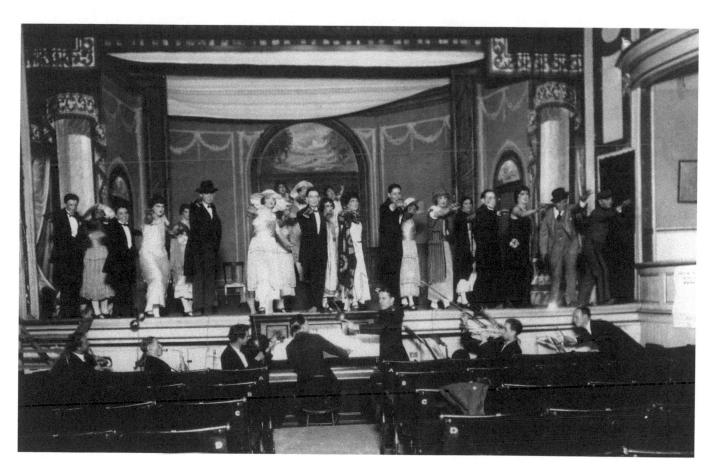

A student group called the Greater Minstrels formed in 1914 to raise money for spectator stands at Fleming Field by putting on a show. That group toured the state from 1915 until 1921, when it was replaced by the Masqueraders. Some of the later group's cast members—all men—are shown here in 1924 during a rehearsal for a show.

When this structure opened in 1913, it was known as the George Peabody Fountain for the Teachers College. It was funded by a gift of $40,000 from the George Peabody Foundation, begun by the man known as the father of modern philanthropy. Following the Civil War, he established a fund to "encourage the intellectual, moral, and industrial education of the destitute children of the Southern States."

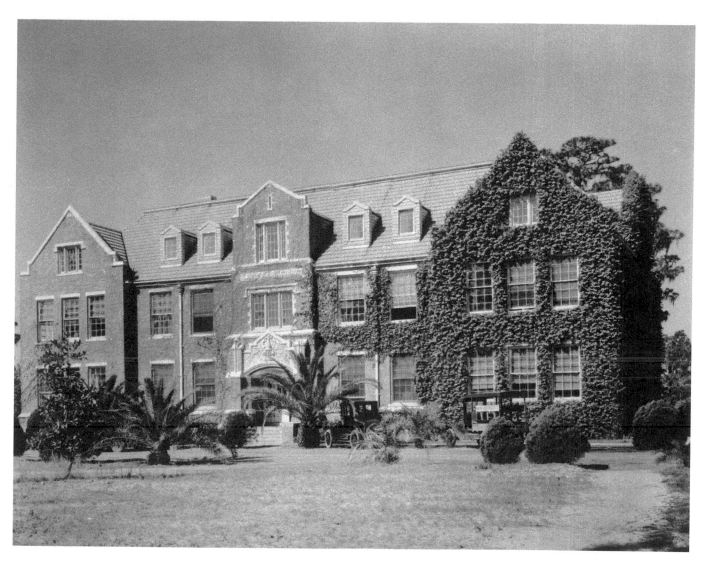

After a long period of use as a storage building and standing essentially abandoned, Floyd Hall was scheduled for demolition. To save it from the wrecking ball, Ben Hill Griffin, Jr., donated $2 million, which made renovation possible in 1992. It was enamed Griffin-Floyd Hall to honor its new benefactor as well as the early assistant dean of the College of Agriculture.

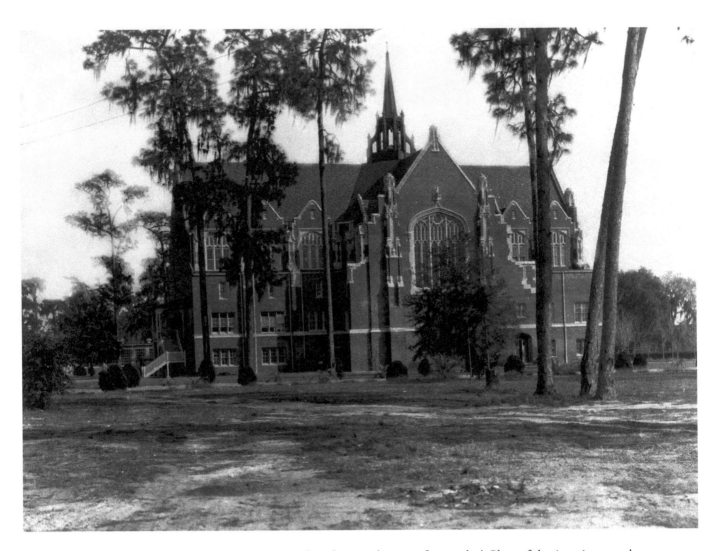

Construction of the large auditorium, located just south and across the street from today's Plaza of the Americas, was begun in 1922. It featured a chapel and a large pipe organ, and was intended for assemblies and concerts. Because of a lack of funds, construction was halted in 1925 and instead of an elaborate facade, what was placed on the north (at left in this photograph) was an exterior wooden stairway.

A quartet of Gator football players seems poised to sack the photographer during the era when games were held at Fleming Field. Used also for baseball, Fleming's first stands were located at the northwest corner of the grassy athletic area. More bleachers were added in the mid-1910s along the sides of the field, affording a better view of football games.

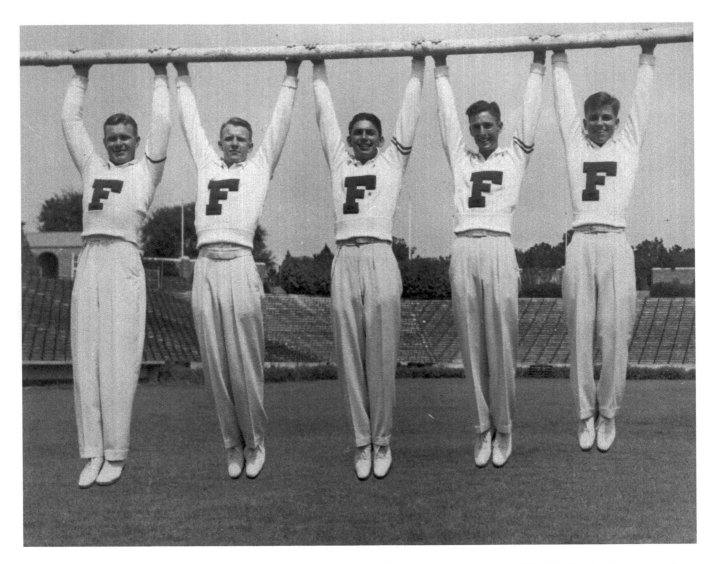

Five cheerleaders were photographed hanging from a goal post in the days when all University of Florida cheerleaders were male. The school's first two female cheerleaders, Berenice Proctor and Eunice Nixon, were allowed to participate in 1937. They had to furnish their own white blouses, flannel culottes, and sleeveless blue sweaters.

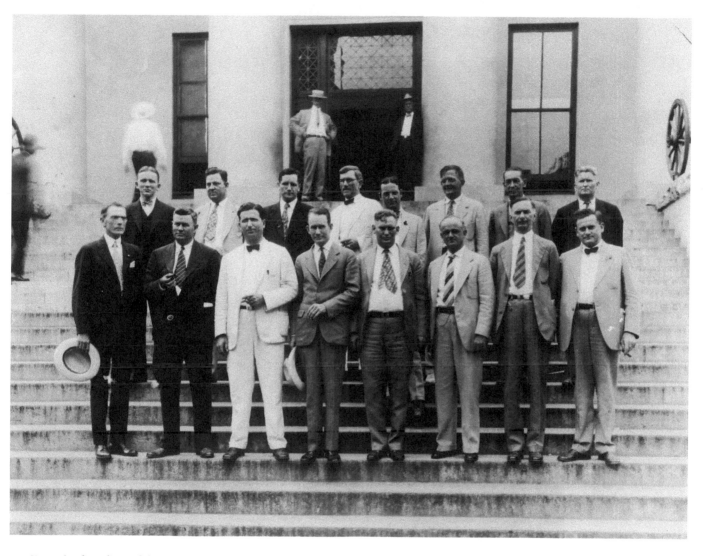

Since the founding of the University of Florida, its alumni have always constituted a significant presence in the state legislature, and occasionally have gathered for a group portrait. This one made in 1927 included Fuller Warren, a future governor. He is standing in the back row, all the way to the left. Technically, he did not qualify as an alumnus, since he was elected to the Florida House of Representatives that year while still a 21-year old student.

Activities of the Agricultural Experiment Station were not limited to those on the Gainesville campus. Extension agents work throughout the state to improve agricultural methods. Shown here in 1928 is a UF beekeeping project at Cook's Apiary, located in La Belle, along the Caloosahatchee River in Hendry County.

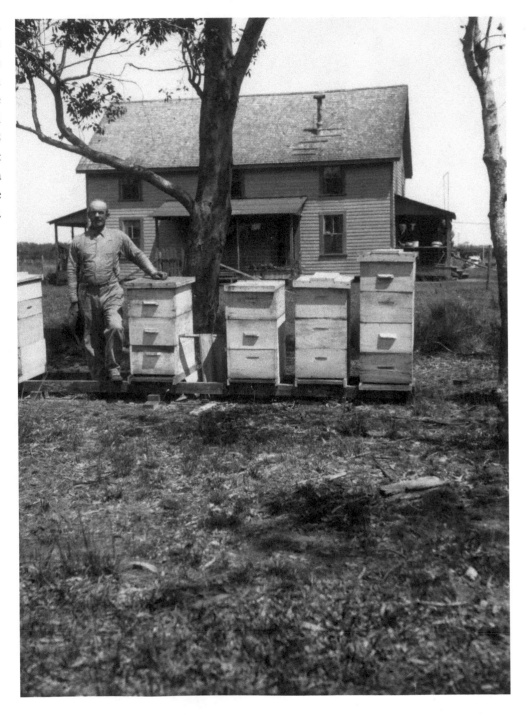

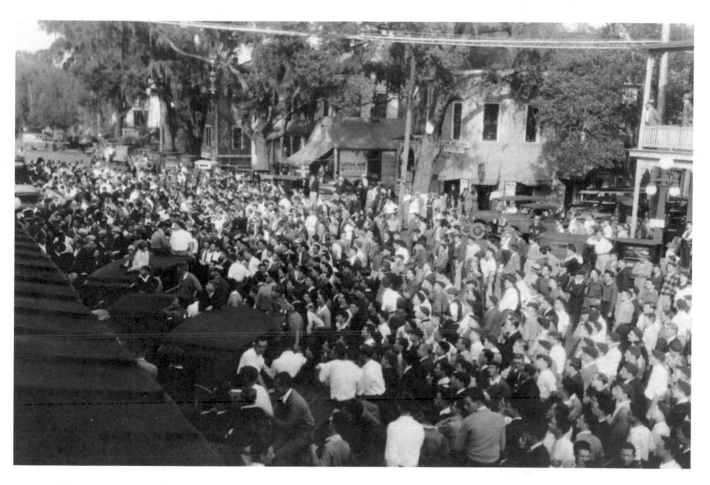

The University of Florida was on the verge of having its first undefeated football season in late 1928, under Coach Charlie Bachman. Two days before the ninth and final game, a huge pep rally on the streets of Gainesville offered an opportunity for fans to express their support. On December 8 in Knoxville, Tennessee, the Gators were beaten by the Tennessee Volunteers by a score of 13-12.

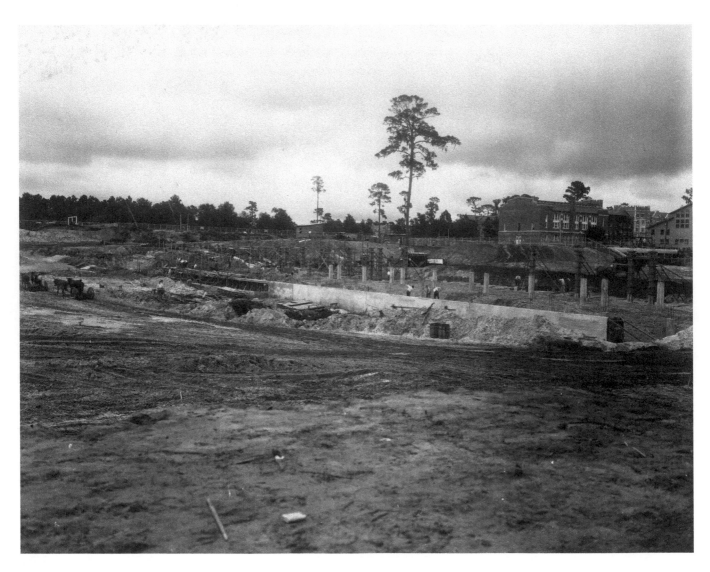

In 1929, Florida Field was constructed in a naturally bowl-shaped area located just south of the original athletic area, Fleming Field. Because of the lower elevation, the tops of the grandstands rose to the same level as the ground surrounding the stadium.

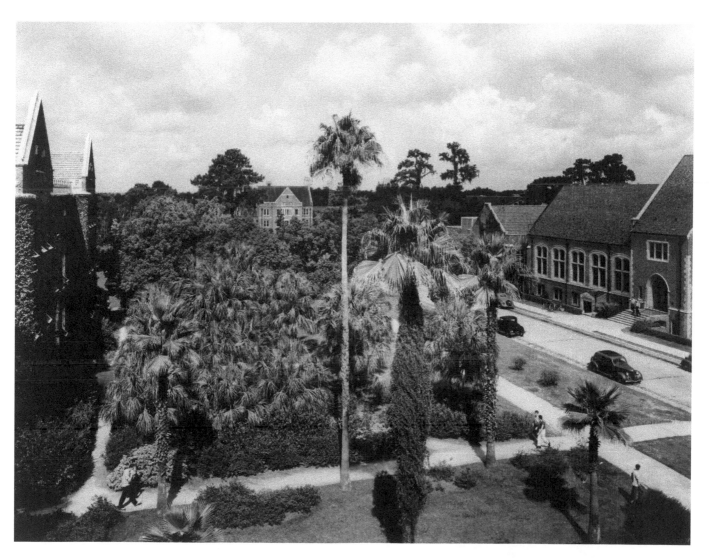

The building in the distance, beyond the dense foliage, is the Infirmary. The first campus facility to treat ailing students was begun in Thomas Hall by the university's first nurse, Leona Bramblett, around 1906. Later housed in a World War I barracks building, it moved into this attractive brick building designed by Rudolph Weaver in 1930. A 1947 wing added a residence for nurses.

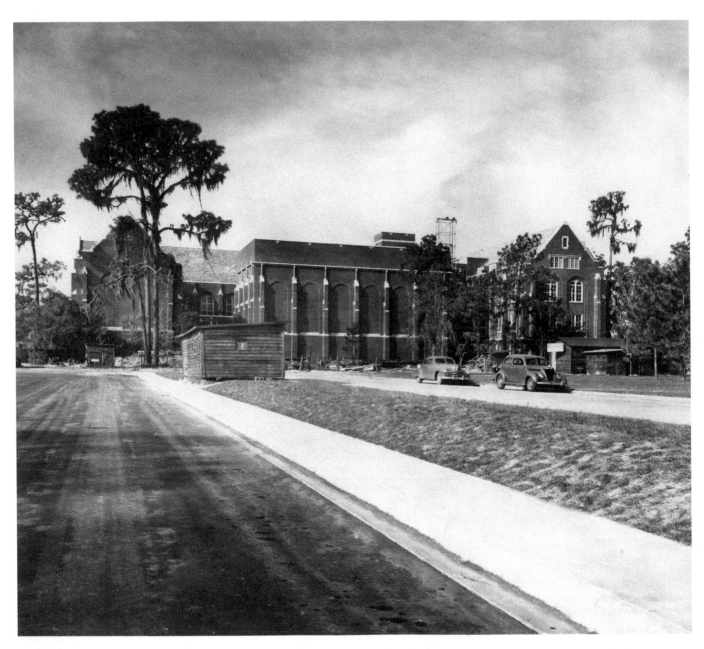

In October 1926, the Collegiate Gothic-style University Library opened as the largest building on campus. It was the last UF building designed by William Edwards. When a second campus library opened in 1967, this one was renamed Library East. In its large reading room is a mural by Hollis Holbrook, entitled *The History of Learning in Florida*.

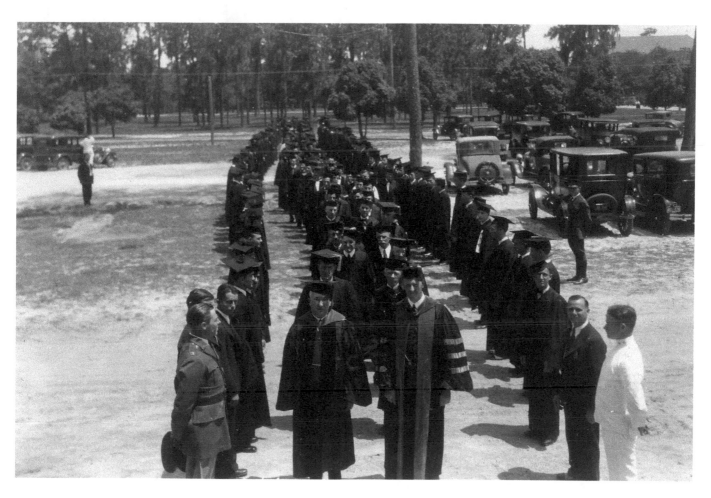

Early graduation ceremonies included a procession of professors through the eastern segment of the campus. Shown here passing between two lines of graduates in June 1930 are members of the faculty near the University Memorial Auditorium.

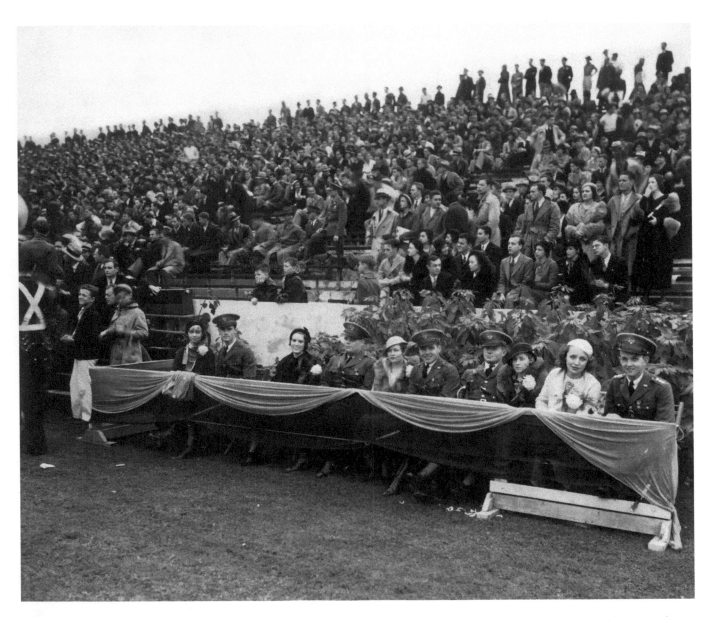

Unlike today's casually dressed students, in the 1930s Florida fans arrived at the stadium in hats, suits, and dresses. These students and guests came to cheer for the Gators at the 1930 homecoming game. The contest ended with fewer smiles when Alabama won by a score of 20-0.

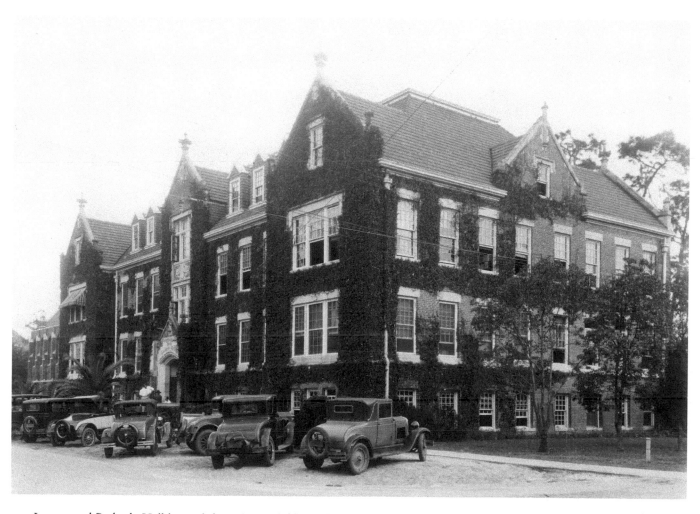

Ivy-covered Peabody Hall housed the university's library from 1912 until 1925. Along with three other Collegiate Gothic-style buildings, it defined the perimeter of the quadrangle now known as the Plaza of the Americas. Until the 1950s, Peabody's third floor was the home of the architecture program.

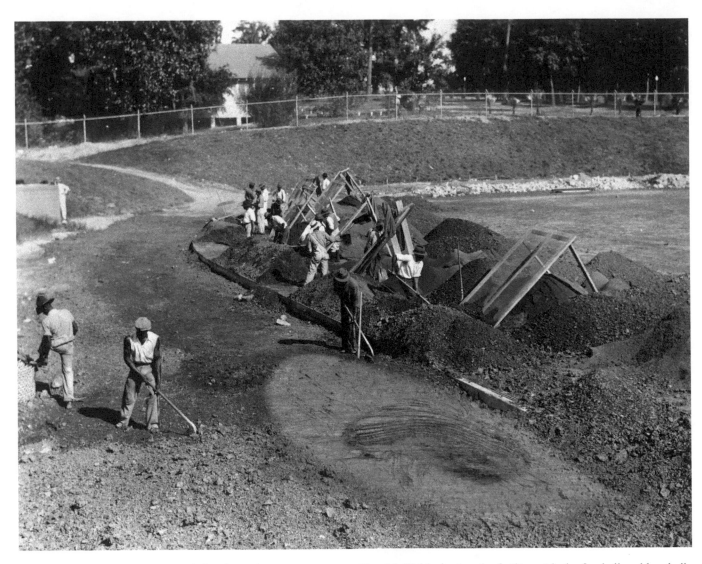

Until the 1930s, the University of Florida track team compete on Fleming Field, sharing the facility with the football and baseball teams. Spectator stands were located near the corner of University Avenue and what was later known as North-South Drive. The track program moved about 2,000 feet to the southwest with the construction of the running track taking shape in this image.

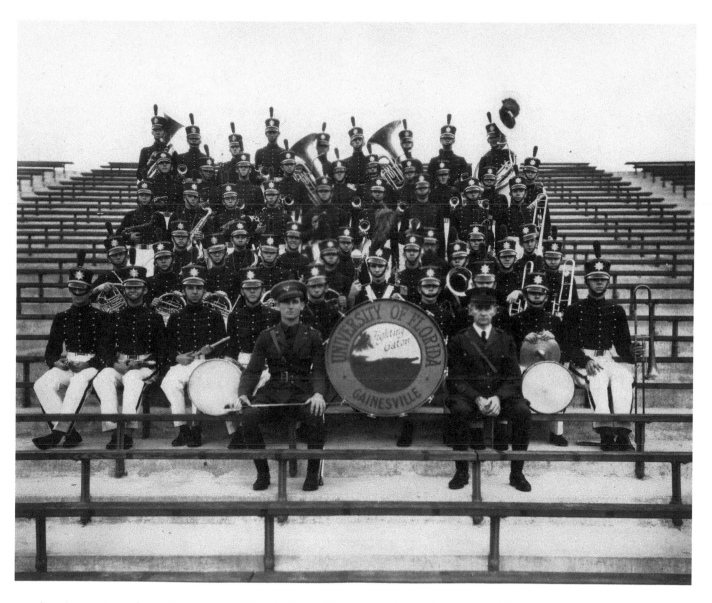

A senior music student volunteer named Charles DuRell "Pug" Hamilton, who composed "Florida Victory Song," became the first director of the marching band when it was formed in 1913. He was succeeded by Lucien Y. Dyrenforth, and then Professor Marks. After World War I, the university hired R. Dewitt Brown, the first paid director who served from 1920 until 1948.

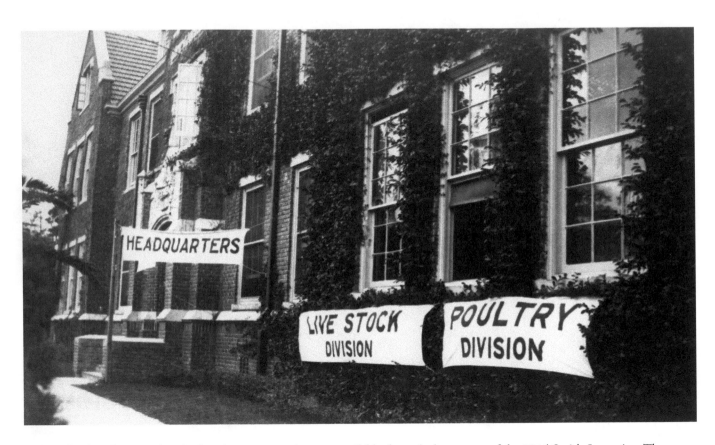

Federal funding for agricultural education programs became available through the passage of the 1914 Smith-Lever Act. The University of Florida used the money to host a series of programs for farmers, turning a portion of the campus into a site for seminars and displays. Shown here are signs from Farmers Week in 1931.

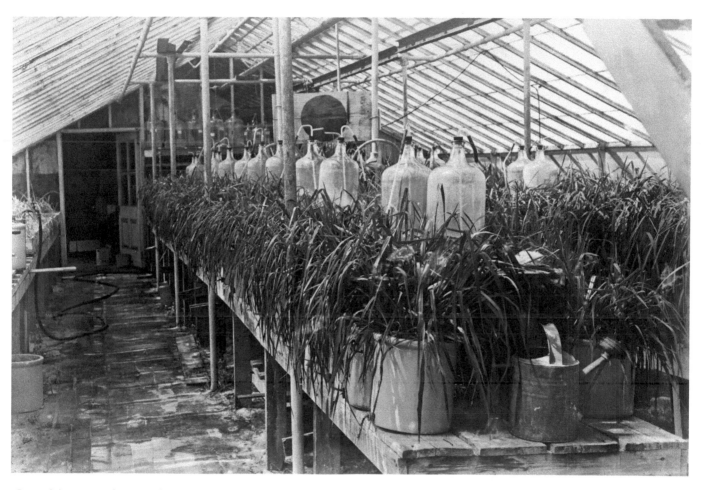

One of the many plants studied at the Agricultural Experiment Station has been bahia grass, native to Mexico and South America. Because it tolerates sand, salt, shade, and periods of drought, it is a popular grass for forage, erosion control, and residential lawns. This is a 1930s image of bahia being grown in sand in a university greenhouse.

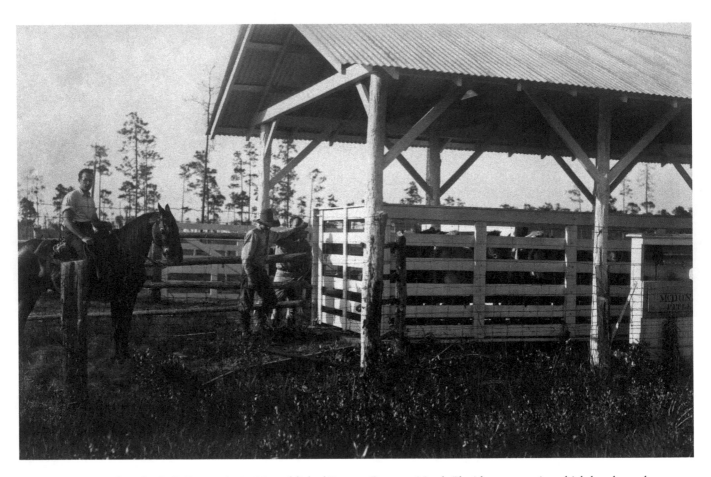

Department store founder J. C. Penney in 1926 established Penney Farms, a North Florida community which he planned as an experimental farming village. Financial conditions at the end of the decade necessitated scaling back the plans, but the Agricultural Experiment Station became involved to salvage some of the experimental aspects of the settlement. Shown here are cattle scales used there from 1931 and 1940.

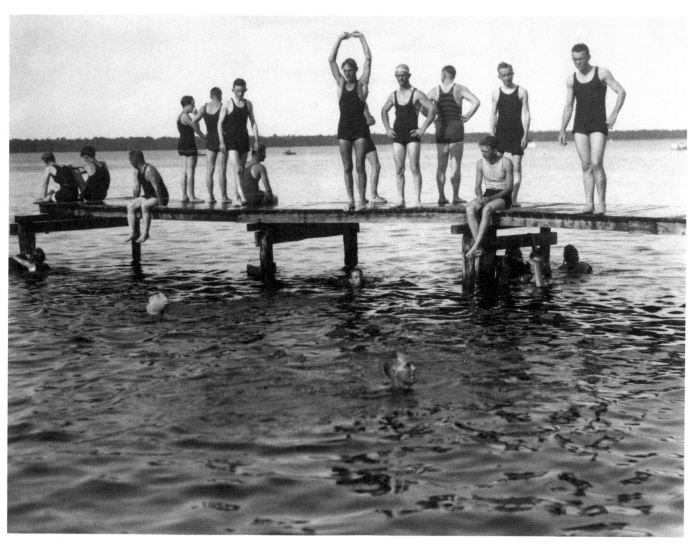

The annual Farmers Week was a time for serious business, but also a time for enjoying Gainesville and its surroundings. A popular nearby place to relax was shoreline property at Lake Wauberg, acquired by the University of Florida from the YMCA during the late 1920s. A recreation center was built in 1939, and the lake is still popular as a leisure destination.

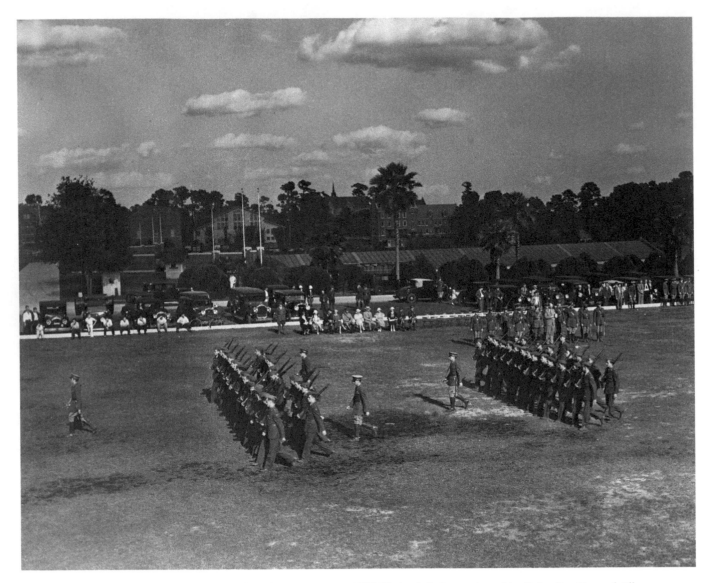

Pictured here on the campus parade grounds is the 1933 Army ROTC brigade being reviewed by Brigadier General Albert Blanding. A graduate of the East Florida Seminary, he served as the Florida state chairman of the American Legion and was a member of the Board of Control which supervised state schools. Not long after this photograph was taken, he was appointed head of the Florida National Guard.

The Future Farmers of America, in addition to promoting careers in agriculture, also fostered athletic competition. Annually, basketball teams from rural communities participated in a tournament held in the gymnasium, which had been rushed to completion in 1919 for use by the visiting New York Giants baseball team. Shown here is the 1934 championship team from Malone, Florida.

Tau Epsilon Phi fraternity's chapter at the University of Florida was founded on February 22, 1925, making it one of the oldest continuously operating fraternities in Gainesville. It is known nationally for being one of the teams in the country's oldest intramural game, the annual Nose Bowl, which for more than half a century has matched the freshmen of Tau Epsilon Phi against those of Pi Lambda Phi.

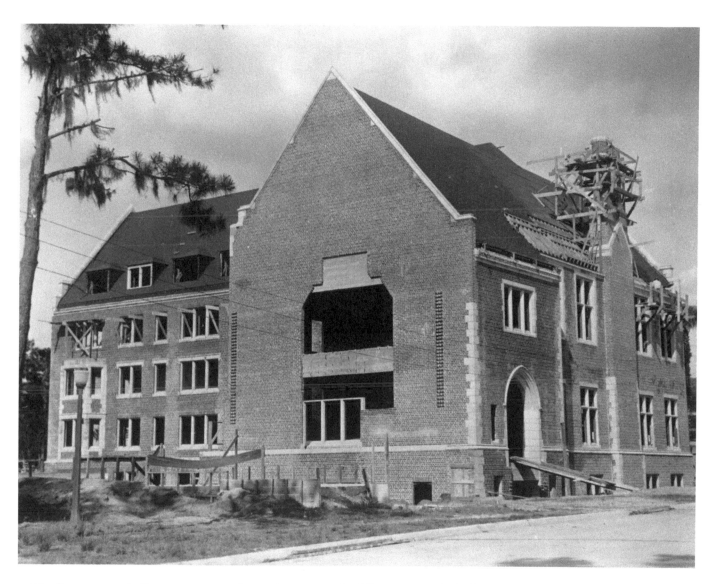

The first structure built to serve as a student union was a Federal Emergency Relief Administration project designed by Rudolph Weaver and completed in 1936. Named the Florida Union, its second floor was used by the YMCA and the Department of Religion, whose chapel's stained-glass window remains. Because it was to include a chapel, William Jennings Bryan helped to raise $79,682 for its construction.

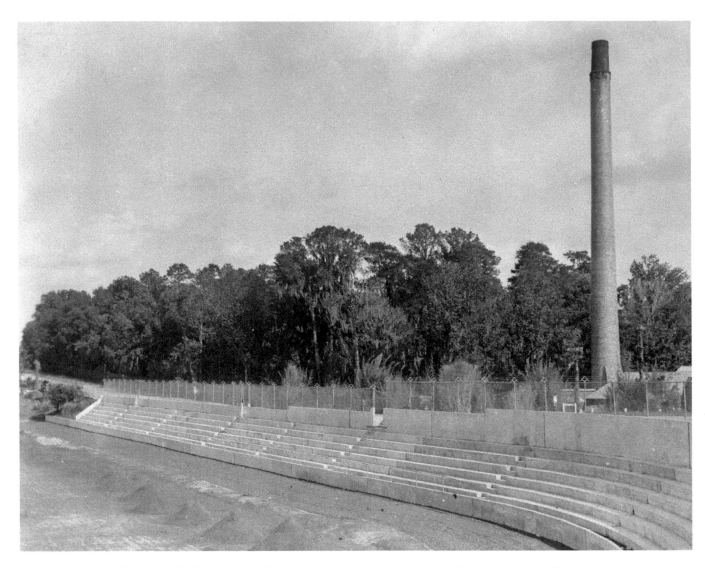

The University of Florida was the beneficiary of several federal construction projects during the 1930s. Shown here is the running track and bleachers built by the FERA, later replaced by more modern facilities. The site is now home to the James G. Pressly Stadium used for track meets and soccer games since 1986, and the Percy Beard Track named for the head track-and-field coach who served from 1937 until 1964.

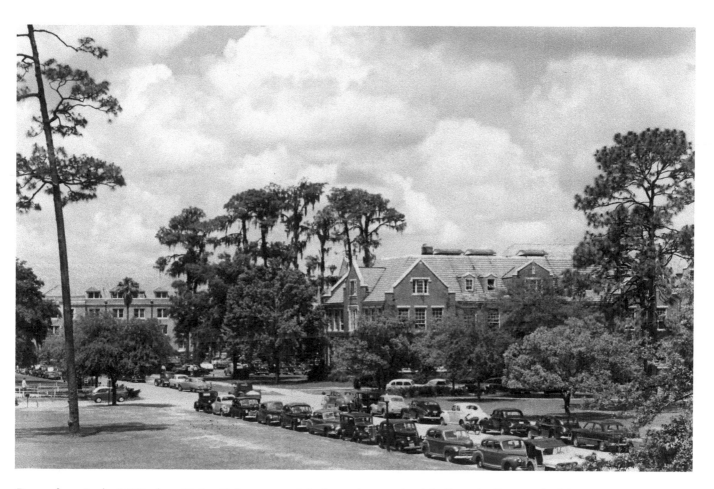

Rows of cars in the 1930s along Union Drive separated the large plaza on the right from the front yard of the University Memorial Auditorium on the left, with Floyd Hall in the background to the right. The auditorium lot reveals scant improvement and was little more than vacant land.

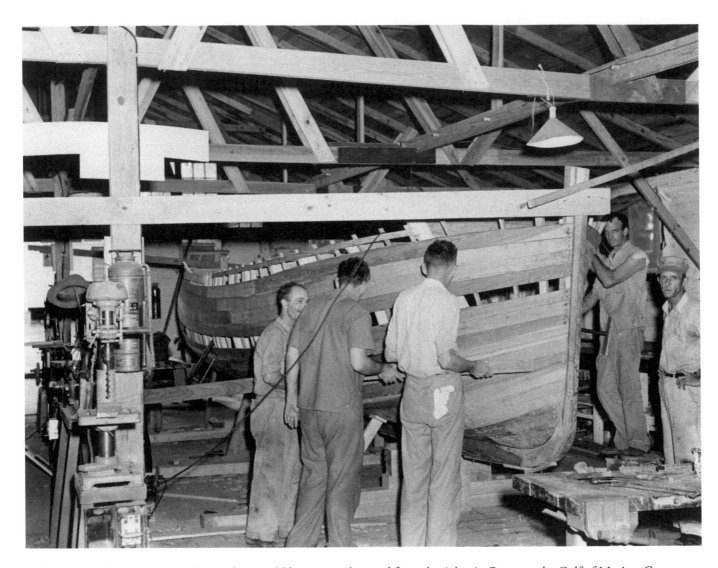

In late 1935, a huge project was begun that would have created a canal from the Atlantic Ocean to the Gulf of Mexico. Camp Roosevelt was built south of Ocala to accommodate crews of the Army Corps of Engineers at work on the canal. Not long afterward, funding problems and environmental concerns terminated the project and the camp became a site for UF and WPA adult education classes, such as this one in boat-building.

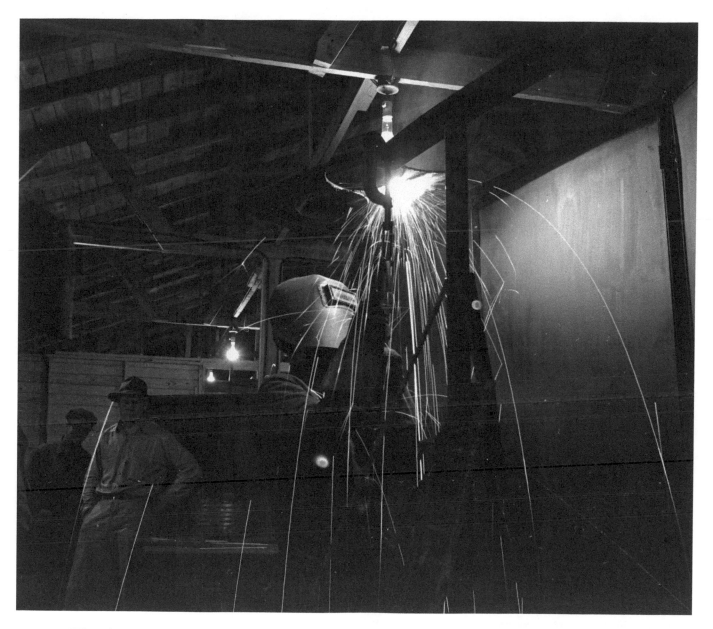

When the WPA and the University of Florida assumed ownership of Camp Roosevelt in 1936, classes were held there in disciplines which included vocations and war-related industries. After about two years, the National Youth Administration used it as a resident camp and then as a defense work facility. By the middle of the war, the army had resumed oversight of the camp. The remaining buildings are today part of a residential neighborhood.

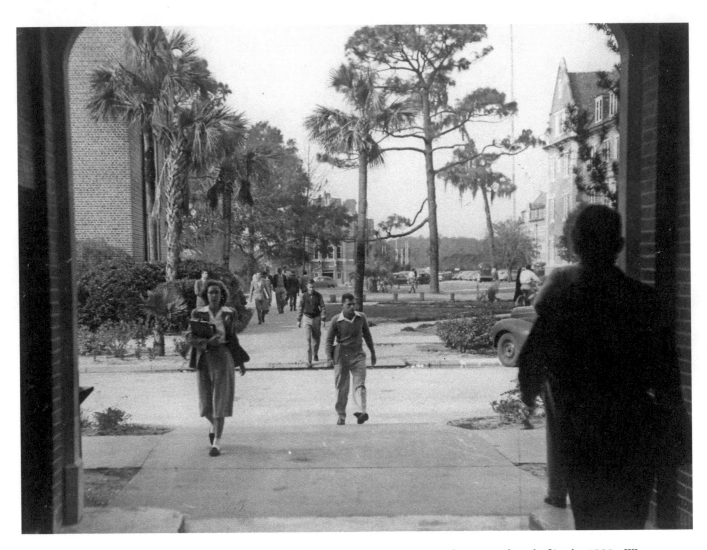

The sight of a female student on the University of Florida campus was uncommon, but not unheard of in the 1930s. Women were allowed to attend summer school and were also allowed to enroll in programs not offered by the Florida State College for Women, such as law, agriculture, and pharmacy.

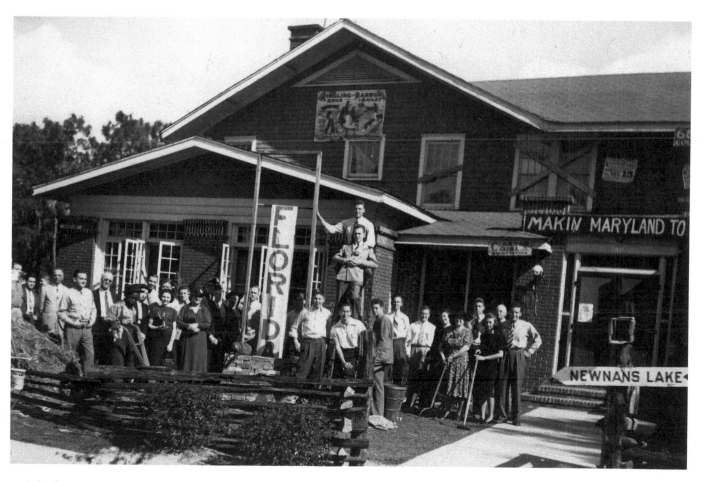

This house, likely the home of an early fraternity, was decorated in anticipation of the 1938 homecoming football game against Maryland. To that point in the season, Florida had won 2 and lost 5, and many feared that Coach Josh Cody would be fired. The Gators won the game by a score of 13-7, and Cody continued to coach through the 1939 season.

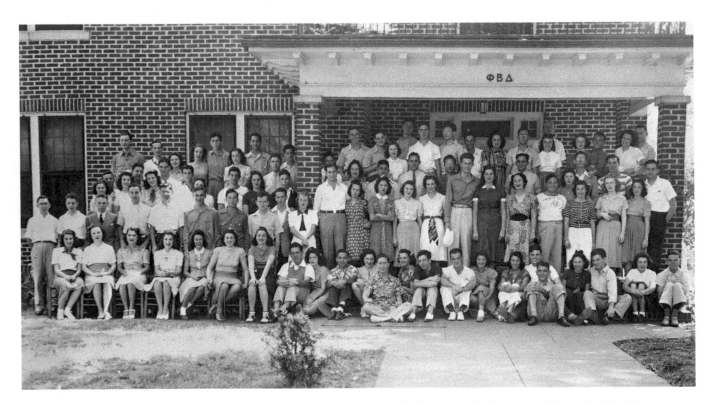

The men in this 1939 image were members of UF's chapter of the national Phi Beta Delta fraternity. Many who joined this fraternity were attracted to it by reason of their Jewish ethnicity, often not welcomed in that day by other fraternities. In 1941, Phi Beta Dela merged with Pi Lambda Phi, which is still active on campus.

The University of Florida has always devoted a large segment of its campus to agriculture, and today a short distance away from state-of-the-art medical, engineering, and other interests can be found crops, livestock, and farm environments. Pictured here in the late 1930s are some of the agricultural facilities serving the College of Agriculture and the Agricultural Experiment Station.

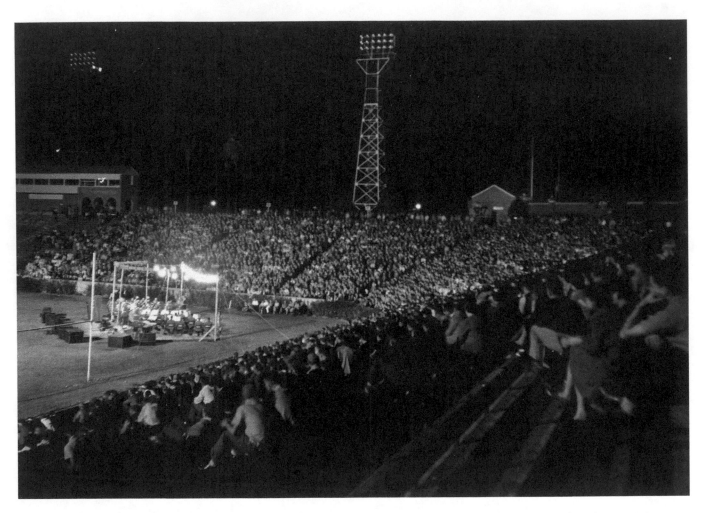

Homecoming, and especially the huge pep rally known as Gator Growl, brings out popular entertainers and quality musicians. Shown here as part of the homecoming celebration for 1940 is a performance by the U.S. Marine Corps Band. The Gator football team did its part to make homecoming memorable that year, beating Maryland by a score of 19-0.

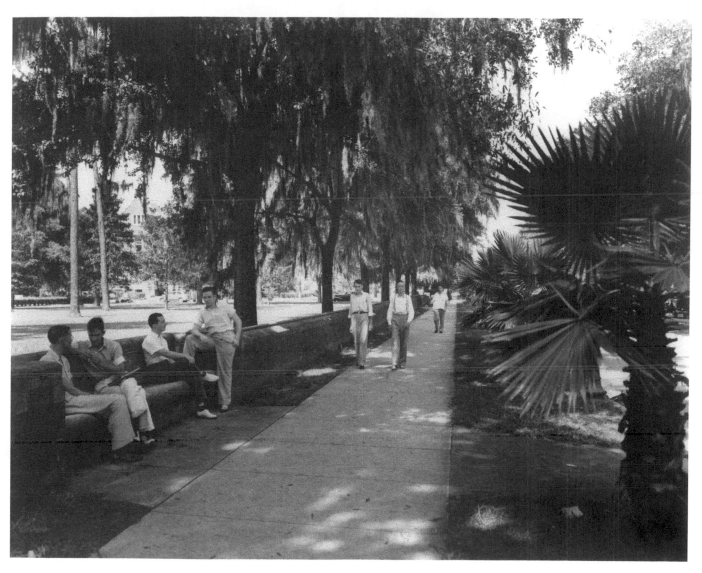

Since the university came to Gainesville, the northern edge of the campus has been defined by the road behind and parallel to this long wall and walkway. Although a few individual buildings across the road have been used for various purposes by campus organizations, the boundary of the campus is still marked today by University Avenue, known as Alachua Avenue before the university came to town.

W. McKee Kelley planned to make his Kelley Hotel the first skyscraper in Gainesville. Begun in 1926, it was incomplete when Kelley abandoned the project. After about a decade, construction resumed with funds from UF benefactor Georgia Seagle and the Works Progress Administration. Renamed the John F. Seagle Building, from 1937 until 1979 it house university offices and the Florida State Museum.

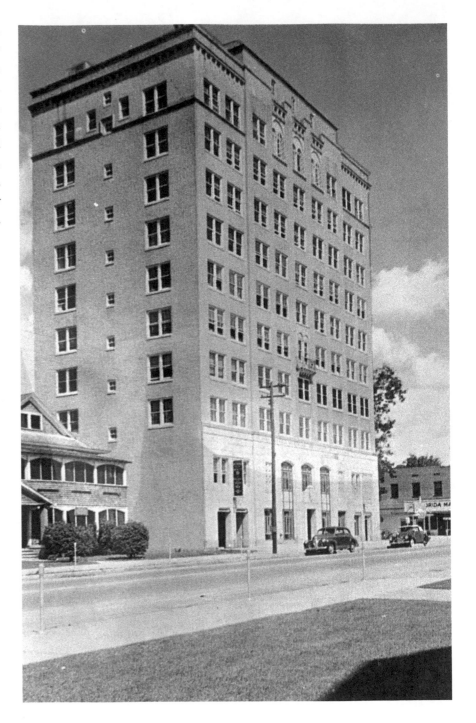

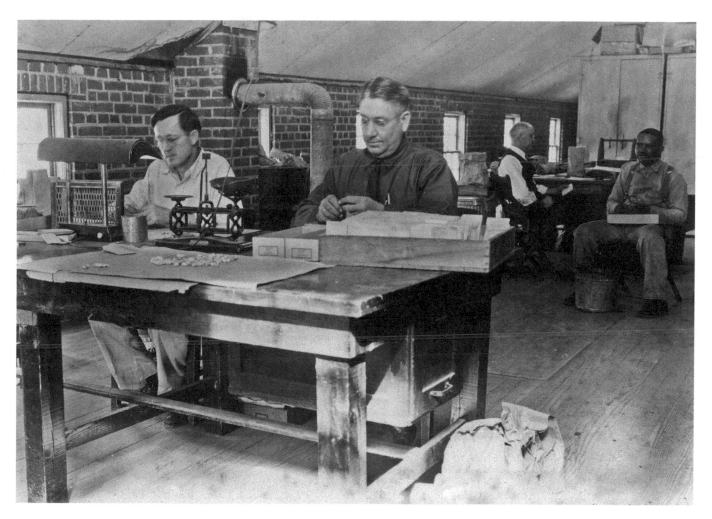

Several varieties of peanuts were developed at the university through the 1960s, with the Florunner variety producing a crop with increased yield and desirable oil quality. It was adapted to the long growing seasons of Florida and Georgia and at one time was grown on more than 70 percent of the nation's acreage devoted to peanuts. Shown here are men examining a crop of peanuts.

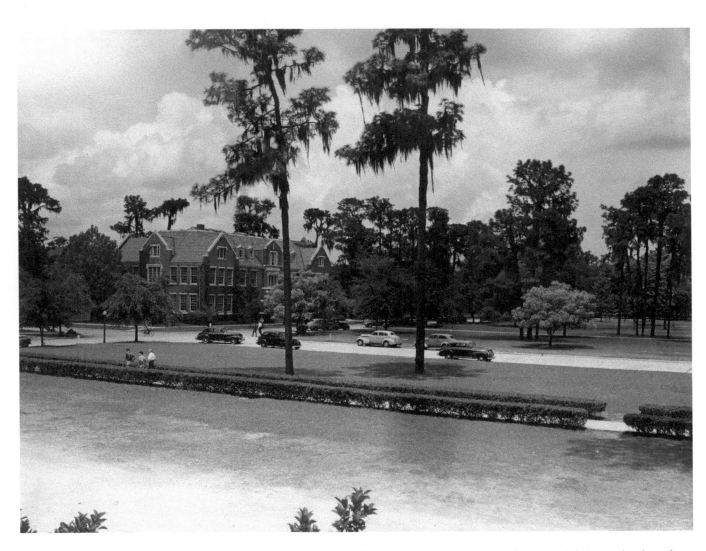

This 1940s view is from near the north facade, then unfinished, of the University Memorial Auditorium. It happened to be a day when few students were taking advantage of the popular parking spaces along Union Drive. The hedge had recently been added along the sidewalk cutting across the lawn.

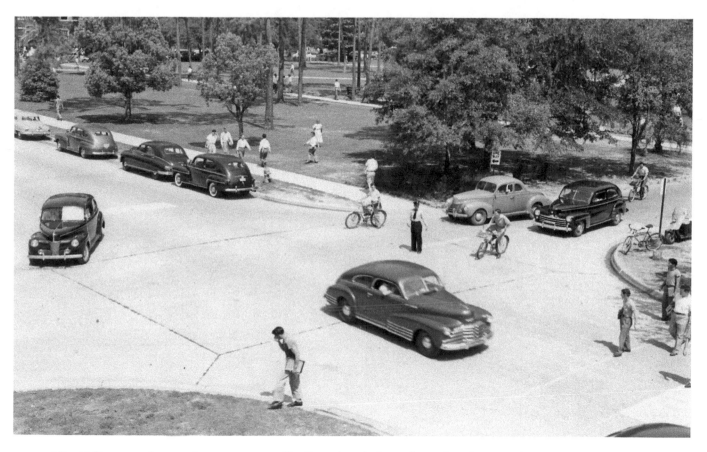

The 1940s saw an increase in on-campus traffic. Even though the traditional student population was not large, the military presence on campus during World War II kept things moving. Traffic control measures had to be implemented, such as designating some roads "one way" and bringing in a policeman to direct traffic through this intersection.

In the early days of World War II, much of the campus looked this way. Pine trees draped with Spanish moss were abundant, shading stately brick buildings, but few students. Many had withdrawn from the university shortly after the passage of the draft law in 1940, to enlist in the armed forces rather than be drafted.

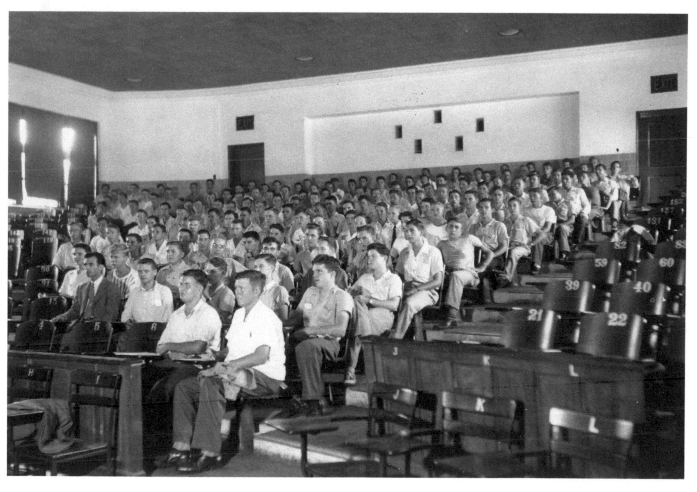

Today's University of Florida incoming freshman classes dwarf the entire student body of many small colleges, but during World War II many young men joined the military, either voluntarily or through the draft, instead of going to college. Shown here is the entire freshman class of 1943, which did not even fill this lecture room in Leigh Hall.

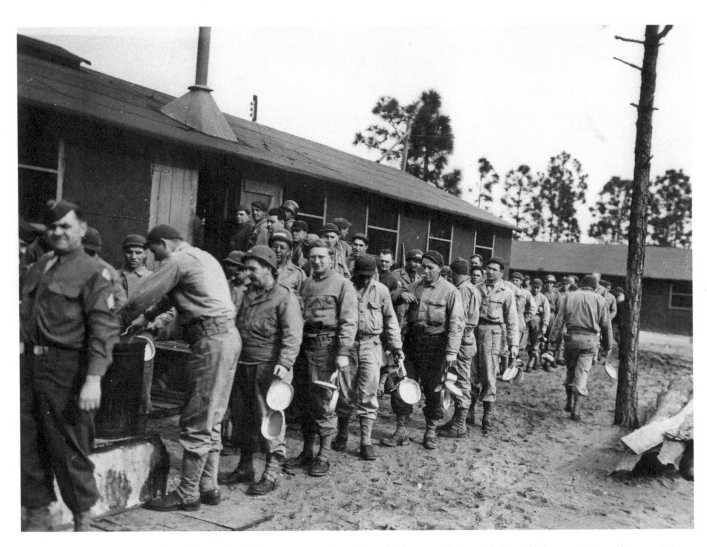

The United States instituted a military draft for young men in 1940, which spurred the withdrawal of many UF students to join the armed forces. The exodus from the campus increased after the attack on Pearl Harbor, following which the university arranged with the federal government to become a training center for troops, some of whom are shown here in 1943.

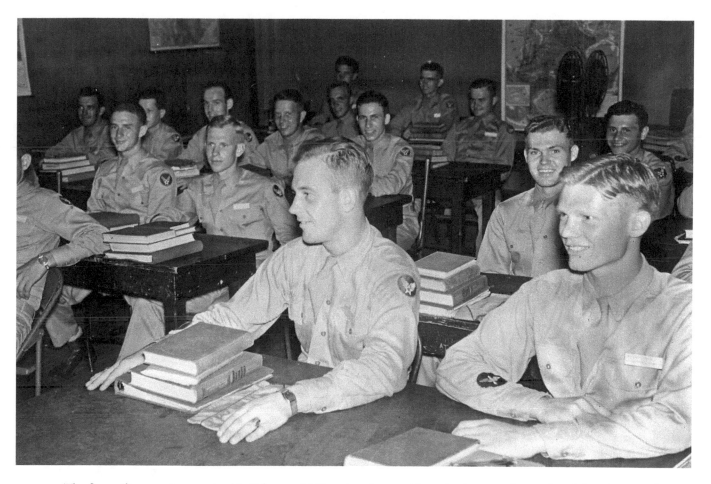

The first military trainees arrived in February 1942 and took up residence in the sparsely populated dormitories. The 750 men ate in the student dining room and took part in student social activities. Classes on military subjects were added to the program just for them.

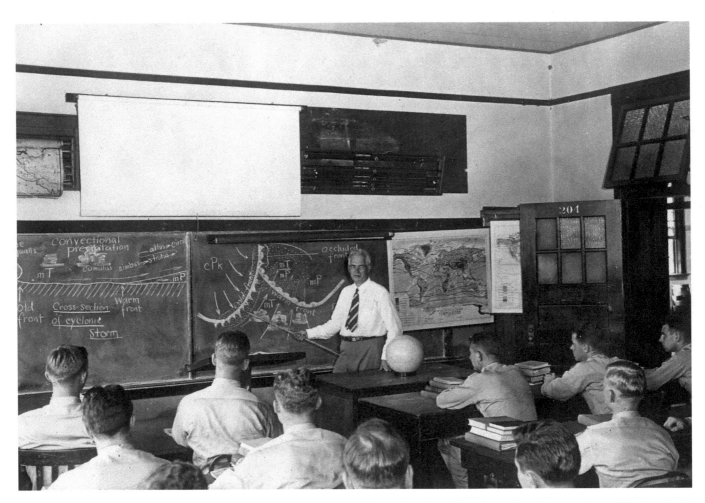

Some classes, depleted by the departure of a substantial portion of the student body, filled up with military trainees. This is a 1943 meteorology class, a science important to both military and civilian concerns.

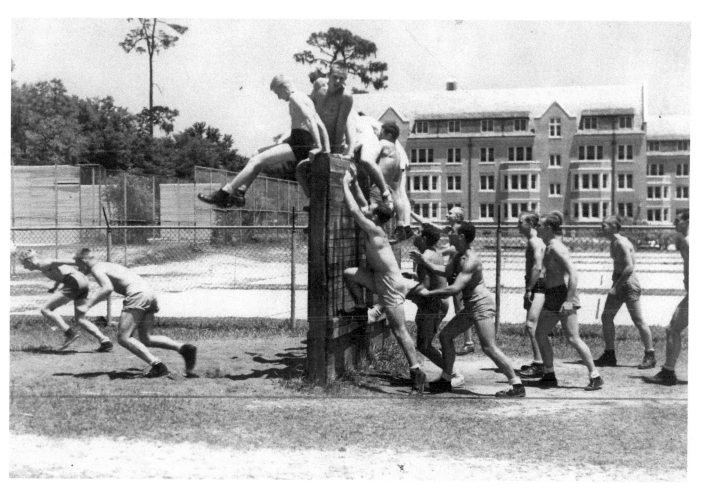

Military trainees participated in a rigorous program of physical education, not unlike their counterparts at traditional army bases. Shown here are trainees running part of an obstacle course located near Murphree Hall.

Those training to be soldiers carried busy schedules of classes and military exercises, but time was reserved for socializing and relaxing. These men seek the shade of a cool brick-covered hallway to enjoy a musical interlude before the next training activity.

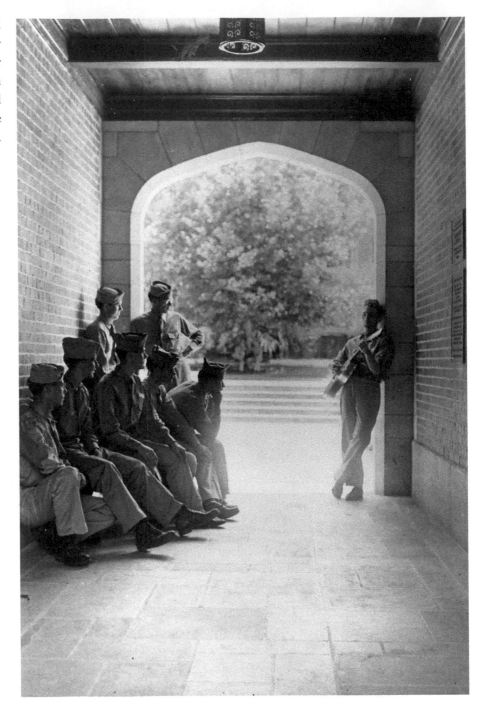

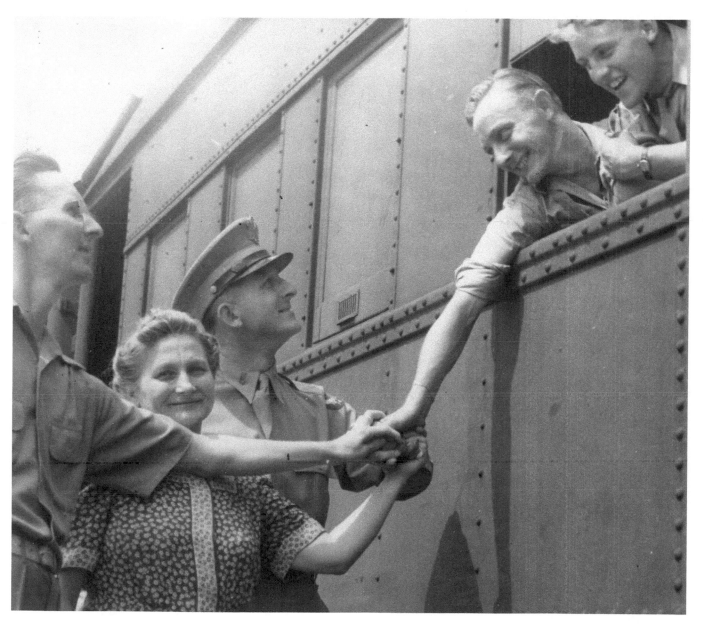

Departure for further training at military bases and deployment overseas could be difficult, but it was also a time for parents, instructors, and friends to express their pride in the commitment the trainees were making. In addition to the military trainees who temporarily occupied the campus, more than 10,000 University of Florida alumni served in the armed forces during World War II. At least 402 of them were killed.

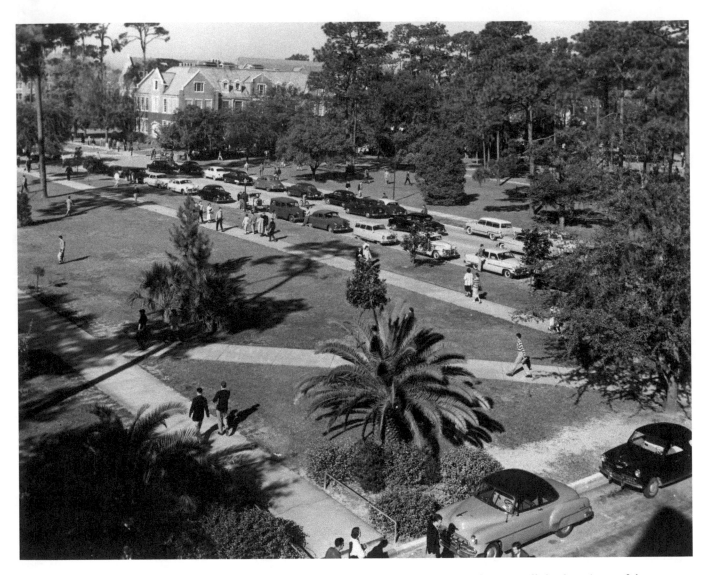

This view from the 1940s shows some improvements to the old portion of the campus. This was still the front lawn of the University Memorial Auditorium, but with concrete sidewalks and an effort to attractively landscape it.

EXCEPTIONAL GROWTH

(1946–1959)

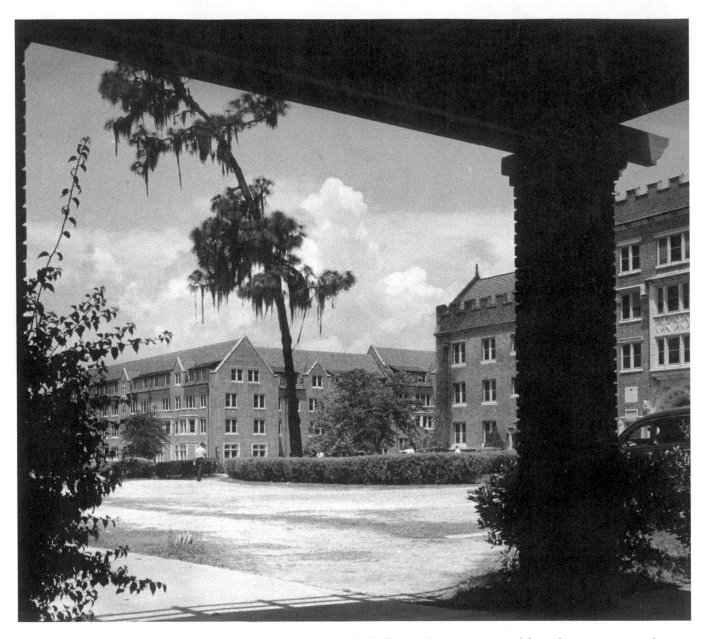

This is a view of the south ends of Murphree (left) and Sledd (right) halls, two dormitories named for early university presidents. Both were designed by Rudolph Weaver with Sledd Hall opening in 1929 and Murphree a decade later. Andrew Sledd led the school from 1904 until 1909, when Albert A. Murphree took over, serving until his death in 1927.

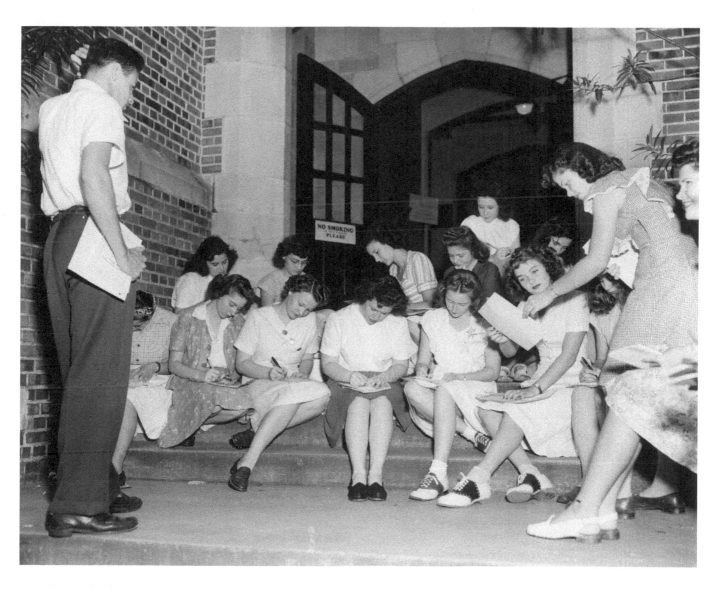

In 1946, John H. Patterson became the first male student since 1905 registered for classes on the campus of the Florida State College for Women (now, Florida State University). Although technically a University of Florida student, he and 506 other men enrolled for the 1946-47 year and shared the campus with the much larger female group, including the students shown here.

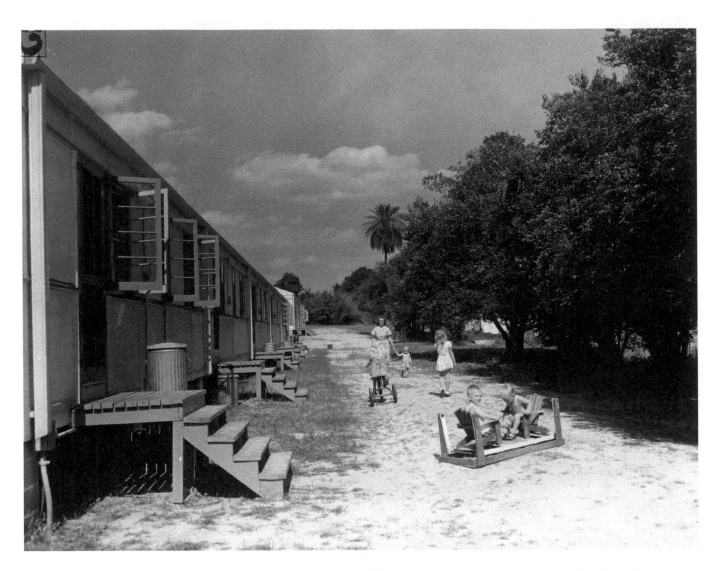

This is one of the former military barracks buildings moved to the UF campus for veterans with spouses and children. The buildings were arranged in villages and each had its own elected mayor and other officials. The Flavet villages were served by a cooperative grocery store and a fire department.

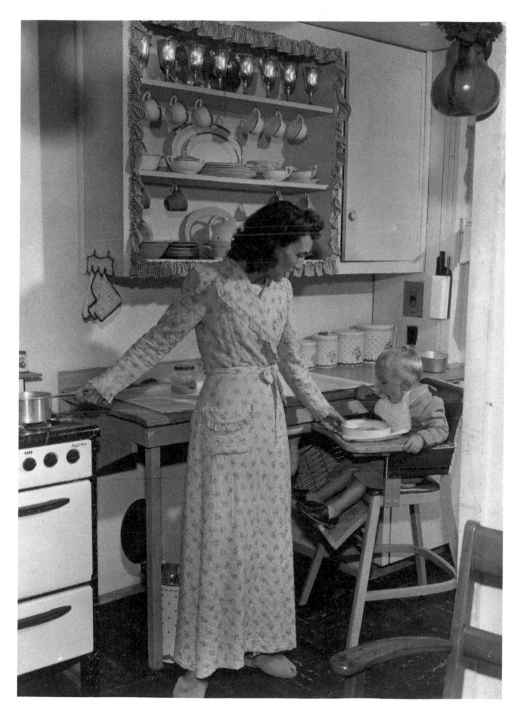

The Flavet (short for Florida Veterans) apartments were not luxury homes by any means, but were comparable to scarce off-campus housing. Gradually, UF satisfied the need for married-student housing with the construction of several on-campus villages, along with the acquisition of existing off-campus apartments. The last of the "temporary" Flavet structures were torn down in 1974, 26 years after being moved to the campus.

The University of Florida is known for its variety of course offerings covering many academic disciplines. One is ceramics, and a student in such a class is shown here in 1946. Today, the Ceramics Department of the School of Art and Art History, a part of the College of Fine Arts, includes undergraduate, post-baccalaureate, and graduate programs.

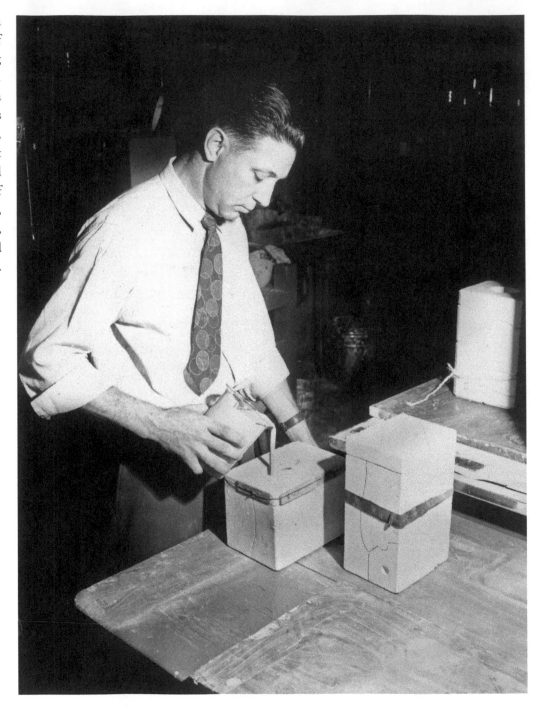

In 1967, a new student union opened and this building, the Florida Union, became the Arts and Sciences Building to house the college of Liberal Arts and Sciences. Eight years later, it was renamed Dauer Hall to honor Manning Dauer, who had been the chairman of the Department of Political Science from 1950 until 1975.

A chapter of the Sigma Chi fraternity was established at UF in 1924, but the national organization is much older than that. Many know of it through the popular song "The Sweetheart of Sigma Chi," written in 1911 by members at Albion College. An important annual social event was the fraternity's Sweetheart Dance, shown here in 1947

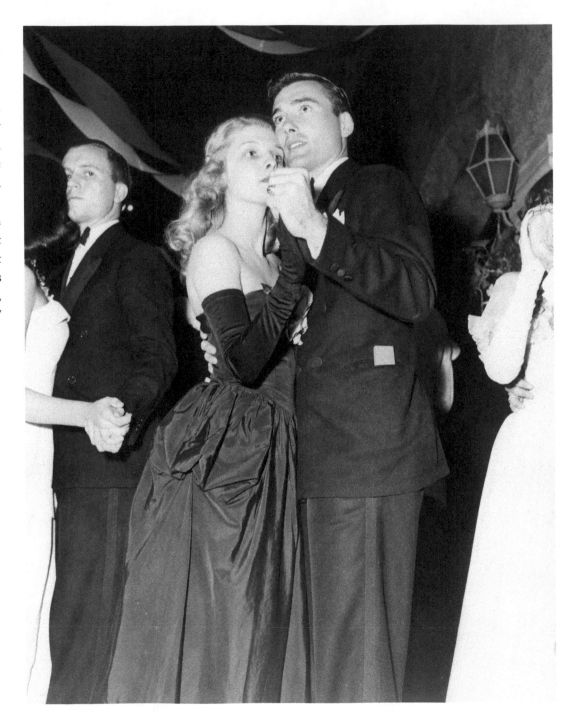

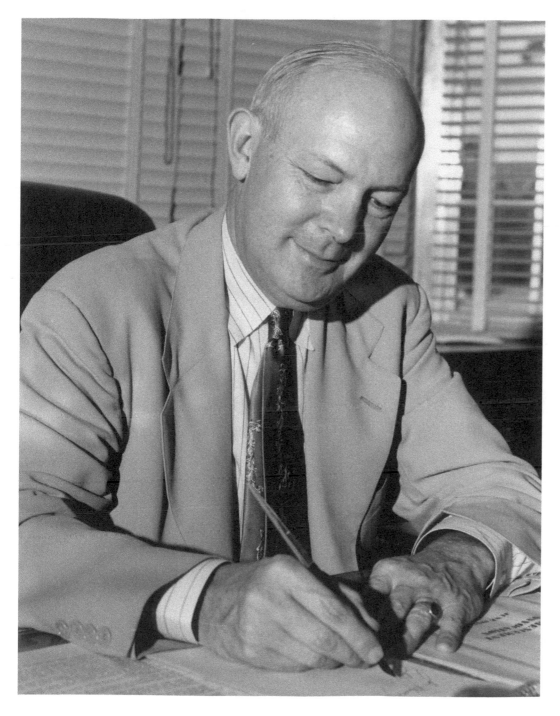

J. Hillis Miller became the president in 1948 during a period of rapid growth. A psychology professor, he had also served as president of Keuka College in New York. His five years as head of the University of Florida carried a twin emphasis on new building construction and staff development. Because efforts to establish a medical school began under his leadership, its large facility was dedicated in 1959 as the J. Hillis Miller Health Center.

In 1919, the National Block and Bridle Club was formed by students in the Midwest to be a social, educational, and service club. Its members worked closely with local 4-H clubs, organizing student rodeo competitions. The University of Florida chapter of the club consisted of students interested in animal science, not just those who were officially majoring in agricultural subjects. They staged this rodeo in 1947, following a parade of performers through downtown Gainesville.

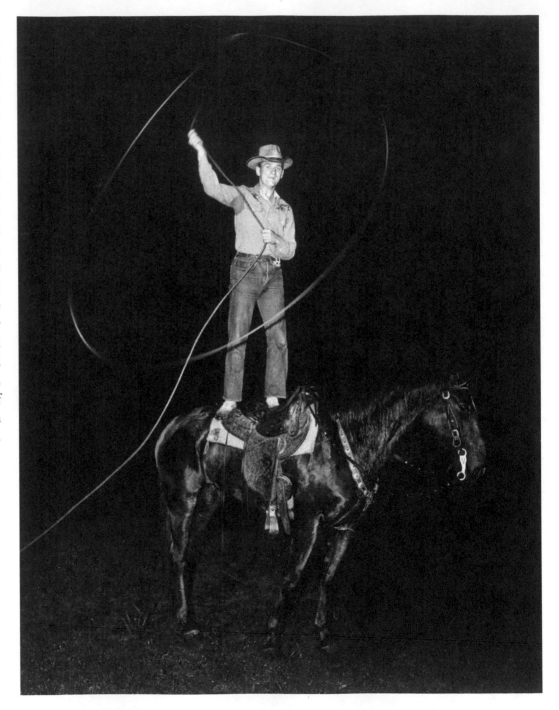

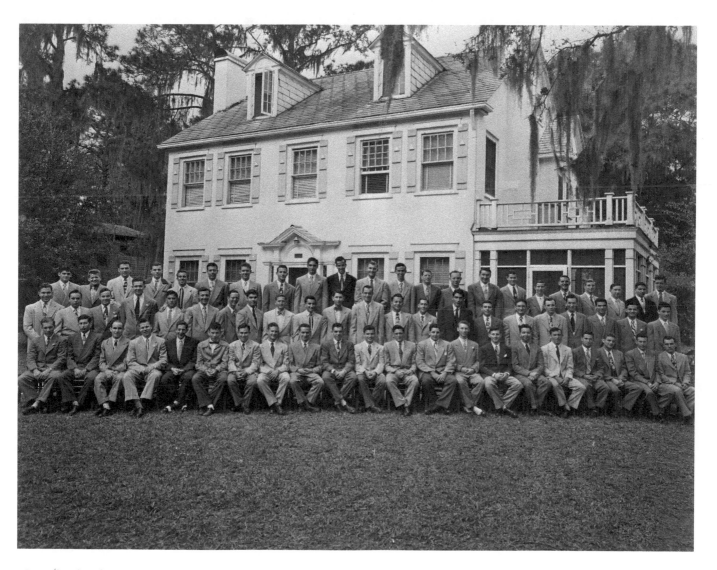

In 1941, the Phi Beta Delta fraternity was going strong on the UF campus, having held the highest fraternity grade-point average for six consecutive years, but nationally the fraternity's 16 chapters needed help. During that year, it merged with Pi Lambda Phi to form a 36-chapter organization which stressed academic achievement and religious tolerance, attracting many Jewish students.

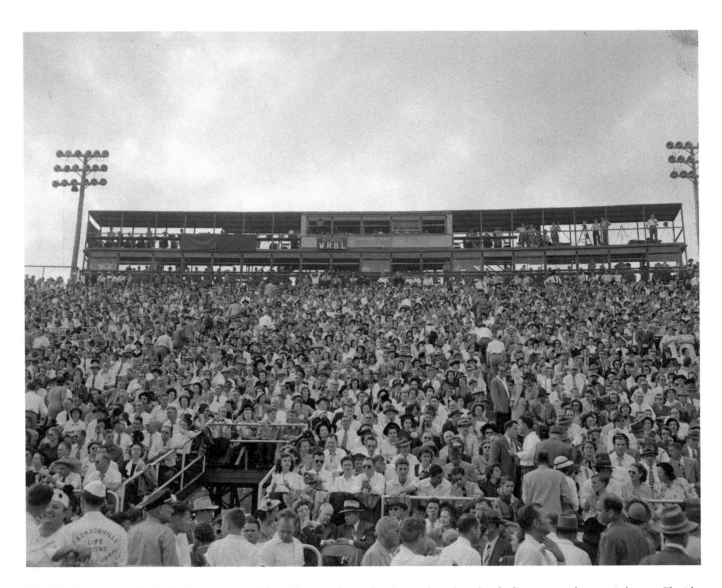

The Florida-Georgia football rivalry is one of the oldest involving the Gators, but the schools disagree on the year it began. Florida begins counting with the 1915 game, but Georgia includes a 1904 game when the University of Florida was located in Lake City. Shown here is the 1948 game played in Jacksonville. The annual game has also taken place in Athens, Macon, and Savannah in Georgia, and Tampa and Gainesville in Florida.

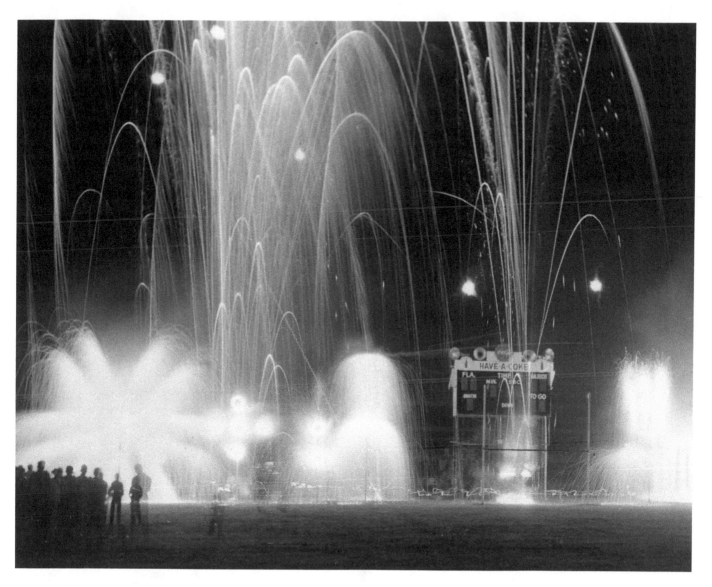

This fireworks display in 1949 provided the finale for Gator Growl, the annual student-run pep rally featuring top-notch entertainment. In the early days, the annual "Dad's Day" provided a time for parents to visit their sons on campus. In 1916, Dad's Day was replaced with a pep rally, and in the mid-1920s skits and musical performances were introduced, which over the years grew into today's huge event.

Through this arch, which affords entry to Sledd Hall, is seen the long facade of Thomas Hall. It was named to honor Major William Reuben Thomas, the Gainesville mayor who lobbied the legislature and offered enough cash, free water, and land to lure the university to the city. Thomas had also been a teacher at the East Florida Seminary, one of the parent institutions of the University of Florida.

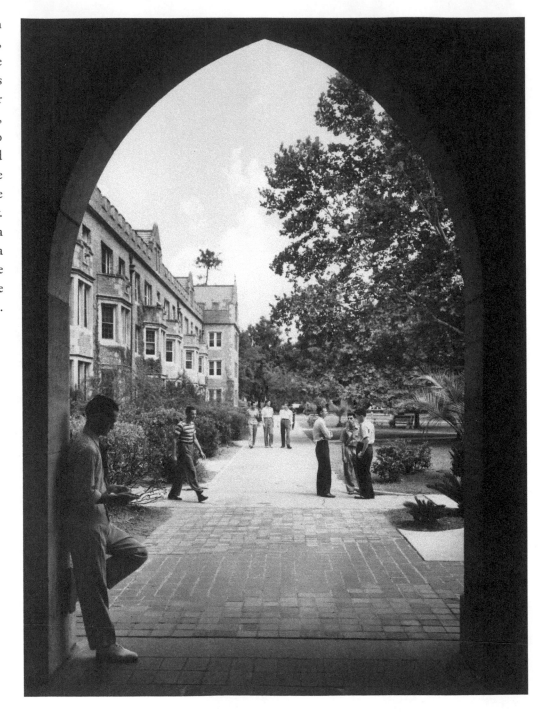

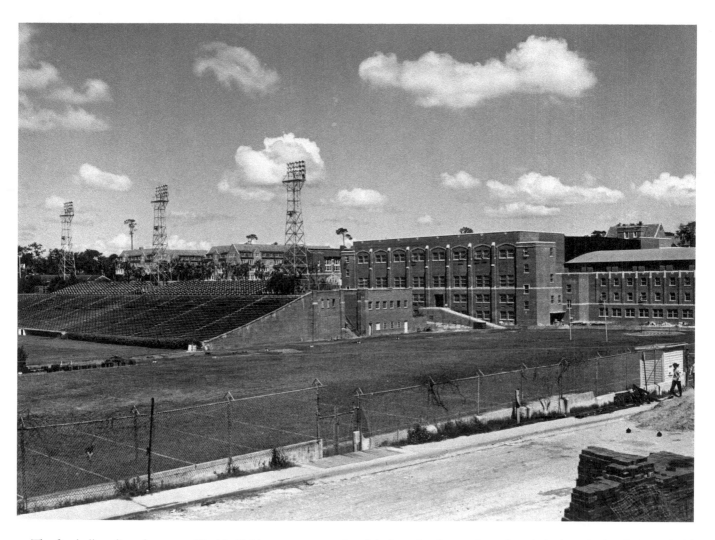

The football stadium known as Florida Field was constructed and dedicated to honor the university's alumni who died in World War I, and their names were inscribed on a bronze plaque at the north end of the facility. Florida Field had a capacity of 21,769 when it hosted its first game in 1930. The adjacent Florida Gymnasium, nicknamed "Alligator Alley," was designed by Rudolph Weaver and opened in 1949.

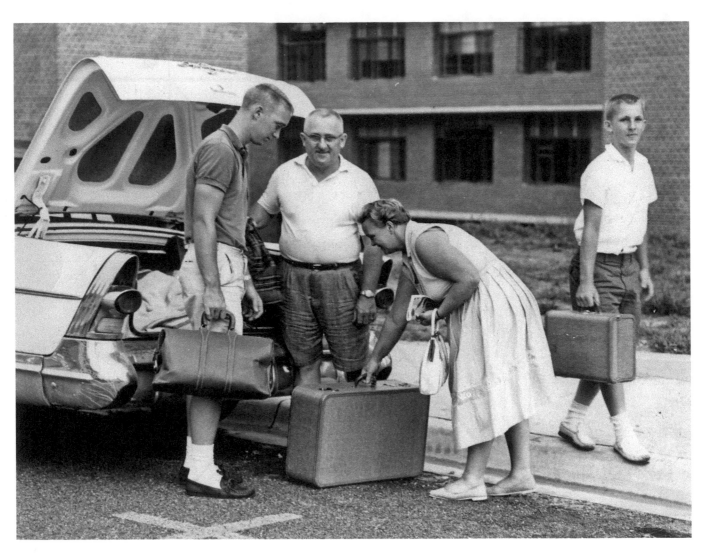

This scene from the 1950s had taken place thousands of times before, beginning with arrivals by train, horse and buggy, and evolving styles of automobiles. Mom and dad and younger brother dropped off the new student, ready to begin his college years in one of the dormitories.

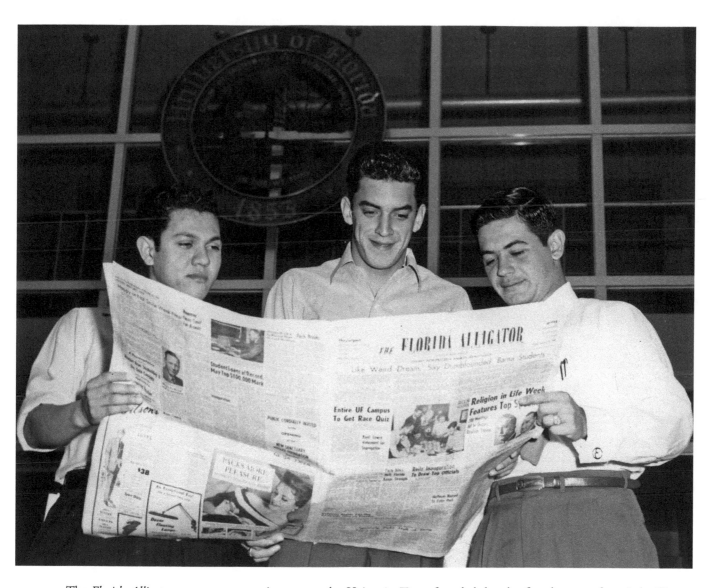

The *Florida Alligator* newspaper traces its roots to the *University Times,* founded shortly after the move from Lake City to Gainesville. From 1912 until 1930, it was published as the *Florida Alligator* by a faculty committee, and then students took over part of its leadership. In 1973, it became officially unaffiliated with the university, but as the *Independent Florida Alligator* is still the student-oriented newspaper in Gainesville.

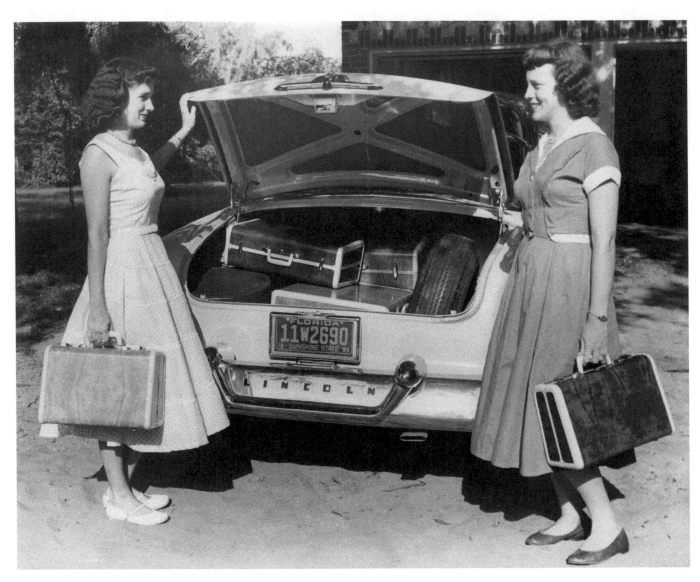

Female students had attended most of UF's parent institutions, but beginning in 1905 with rare exceptions the student body was strictly male. The admission of women students after World War II meant that parents who lived south of Gainesville needed to drive up to three hours less to drop their daughters at a state university.

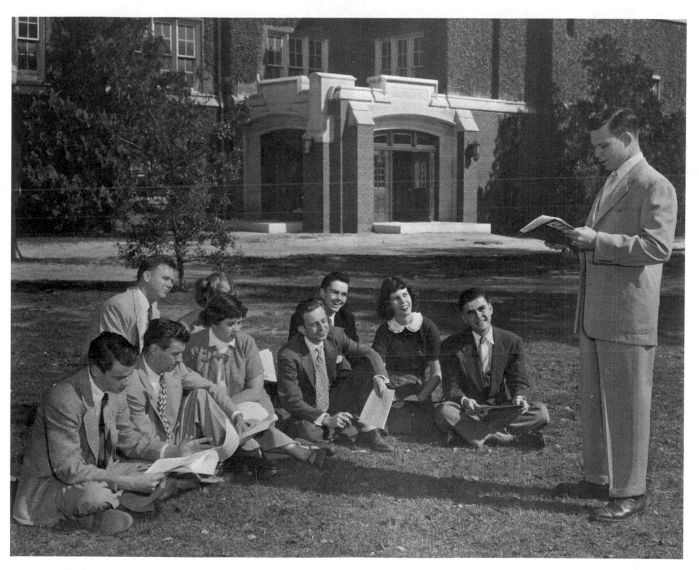

Florida Blue Key is an honorary leadership organization that emerged from the group which organized the first University of Florida homecoming in 1923. Through its Speaker's Bureau, it sponsors an annual speech and debate tournament. Shown here in 1950 training for the Speaker's Bureau is student Melvyn B. Frumkes, who became a nationally known Miami divorce lawyer.

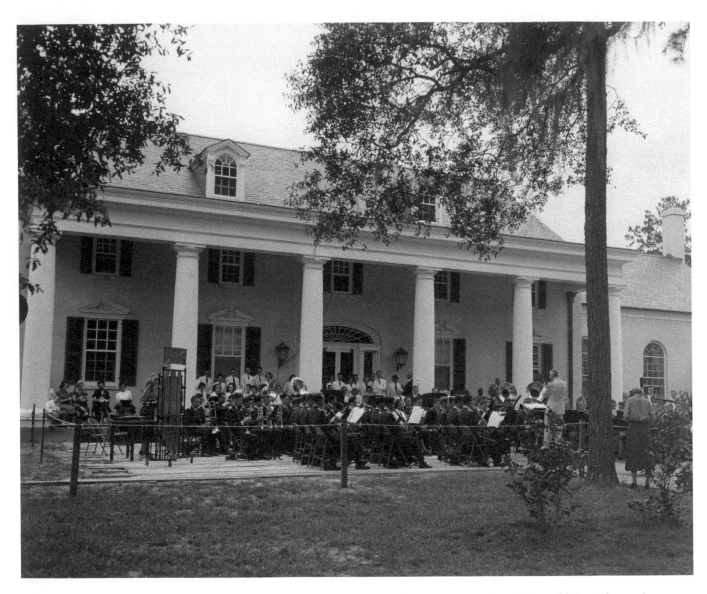

In 1851, Stephen C. Foster wrote "Old Folks at Home," also known as "The Swanee River," and then sold the rights to the song to minstrel leader E. P. Christy, who popularized it. It was named the official state song in 1935, and a memorial park and museum honoring Foster were established along the Suwannee River in White Springs. To celebrate the centennial of the composing of the song, the University of Florida Band (shown here) and others performed at the memorial.

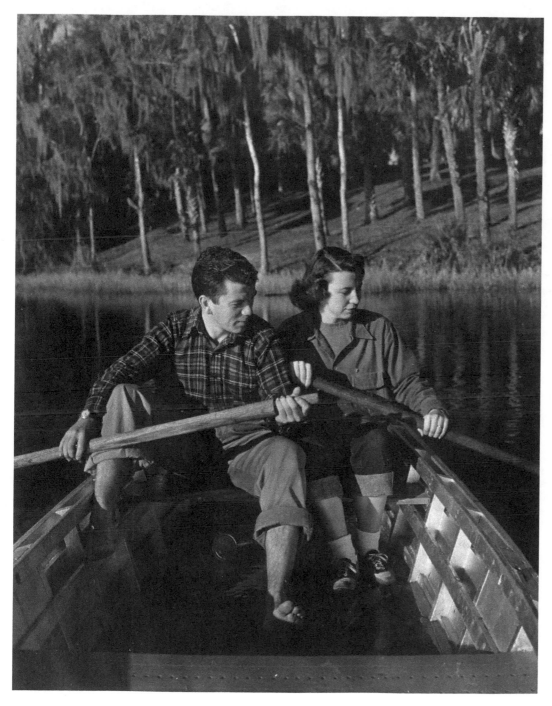

Sigma Chi's Sweetheart Weekend included the naming of the chapter's Sweetheart, an honor for a young woman that was the equivalent to winning a beauty pageant. The Gamma Theta chapter's Sweethearts have included Norma Schaeffner, shown here rowing on Lake Wauberg with Rudolph Adams, and actress Faye Dunaway.

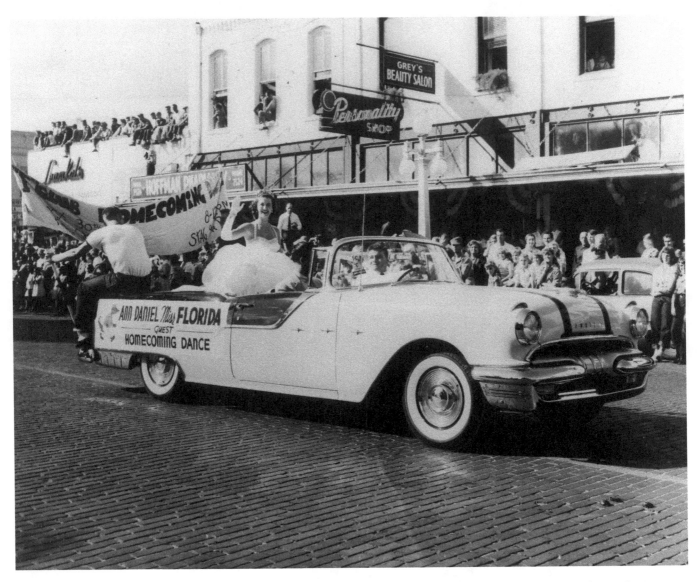

In preparation for the October 30, 1954, homecoming football game, a parade through downtown Gainesville featured Miss Florida, Ann Gloria Daniel, a Dade City resident who attended the University of Florida. In the 1955 Miss America pageant, she played the accordion and was selected as first runner-up. The Gators beat Mississippi State by a score of 7-0 in the football game that followed the parade.

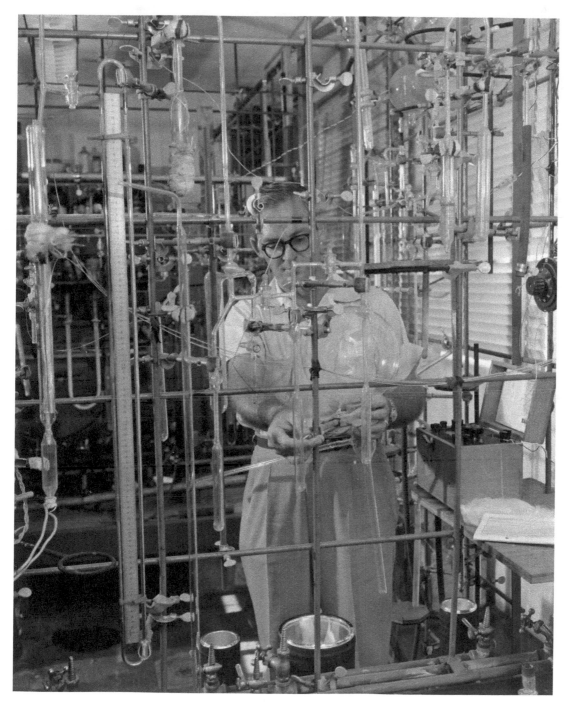

A scientist is pictured here in 1954 in the flouridine laboratory at UF. Flouridine was a subject of research because it slowed the growth of cancer cells, and therefore was a treatment for malignant tumors. A side effect was that it made subjects whose medicines contained the chemical more sensitive to exposure to the sun, and therefore more likely to tan or burn.

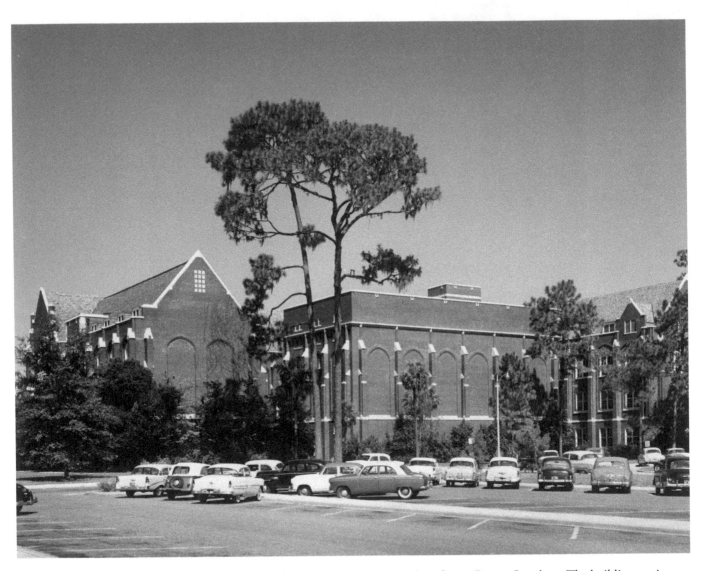

In 1991, Library East was renamed the Smathers Library to honor university benefactor George Smathers. The building retains most of its original architectural character, while accommodating later additions such as the southwest entry to a wing designed by Rudolph Weaver and an entrance foyer designed by Guy Fulton. Its collections included rare books, Florida History, Latin American subjects, and university archives.

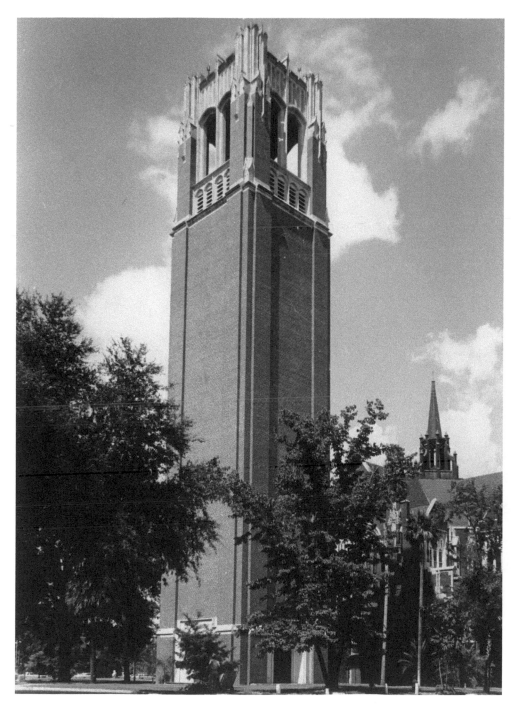

In 1932, a site was set aside for the planting of 13 holly trees in the shape of a "W" to commemorate the bicentennial of the birth of George Washington. In 1953, the trees were removed and construction began on a 157-foot-tall tower designed by Guy Fulton. Begun 100 years after one of UF's parent institutions began receiving financial support from the state, it would be named the Century Tower.

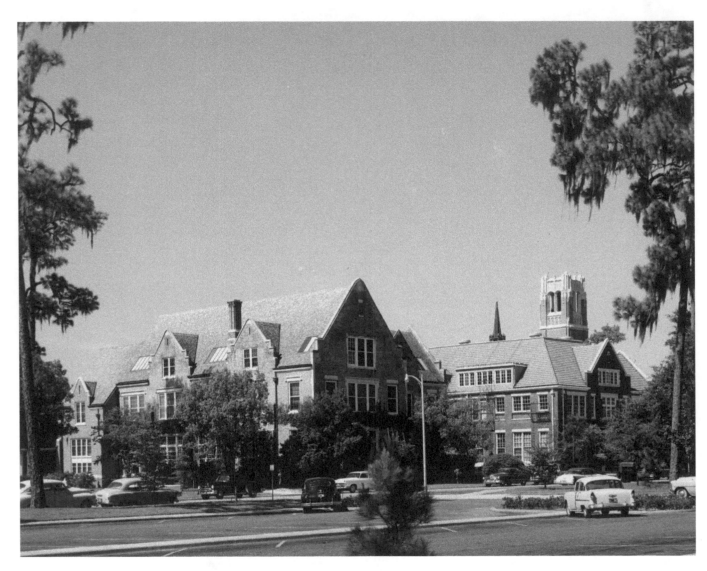

To the left in this 1957 photo was Walker Hall, which opened as the Mechanical Engineering Building 30 years before. Next to it stood Benton Hall, which housed a portion of the College of Engineering from 1911 until it was torn down in 1969. In its place rose Grinter Hall, named for Linton E. Grinter, dean of the Graduate School from 1952 until 1969.

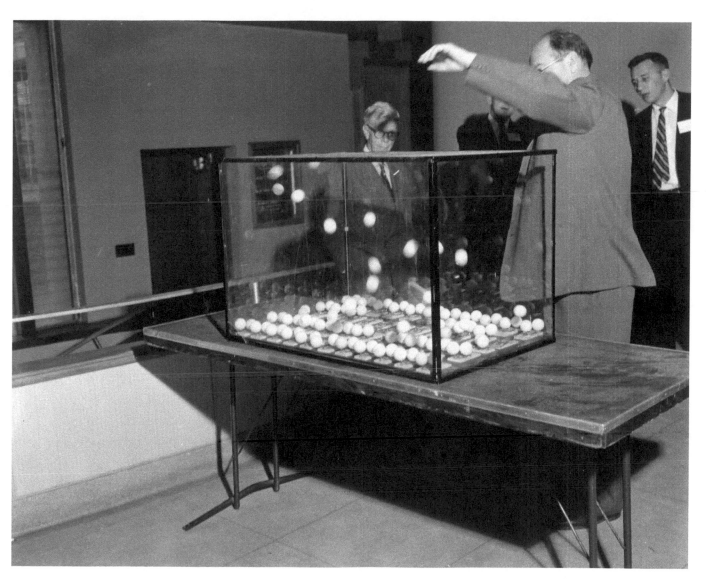

In 1957, there was much concern about nuclear energy and what part Florida should play in its development. A conference held on campus in March of that year instructed newsmen in the basics of nuclear physics and its potential uses, with a keynote address by James Keen, the first chair of the state's Nuclear Development Commission. Shown here is a demonstration of the basics of chain reactions.

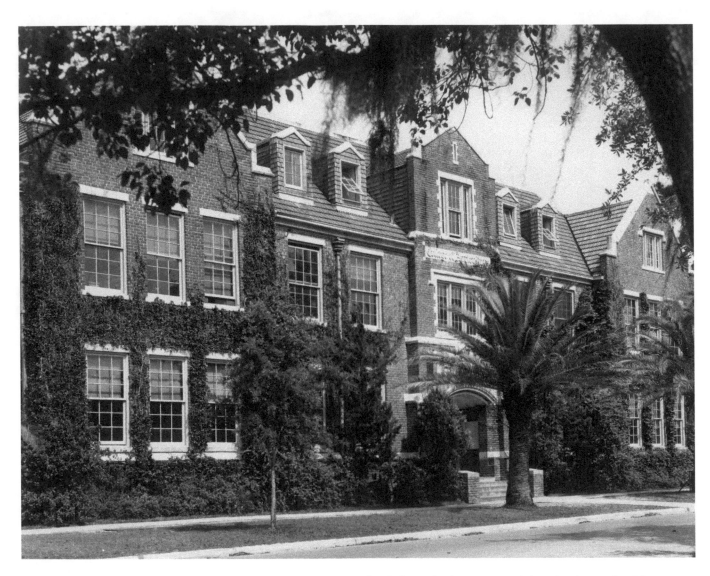

Peabody Hall was the original home of the Teachers College, later the College of Education, until the school moved to Norman Hall in 1934. For a time, Peabody housed the print shop of the *Florida Alligator* student newspaper. A 1990 renovation linked it to Criser Hall to serve as the Criser Student Services Center, which includes offices of the registrar and student services.

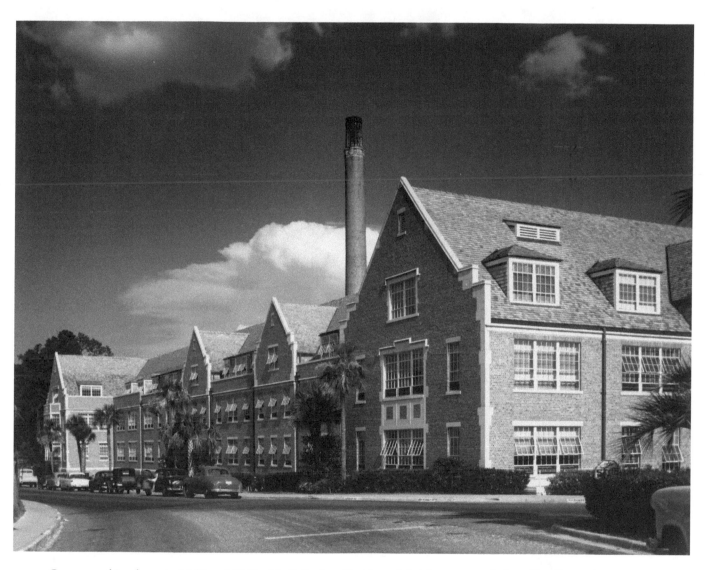

Constructed in phases in 1947 and 1949, this Collegiate Gothic-style brick structure designed by Guy Fulton was originally known as Engineering Industries Building. It was occupied by the College of Engineering, led by Dean Joseph Weil from 1937 until 1963. It was later dedicated and renamed Weil Hall in his honor.

From 1955 until 1967 the president of the University of Florida was J. Wayne Reitz, pictured here giving a speech in Tallahassee in 1959. Reitz had served as the school's provost of agriculture before assuming the presidency. Under his leadership, the university added more than 300 buildings and the student population surpassed 18,000.

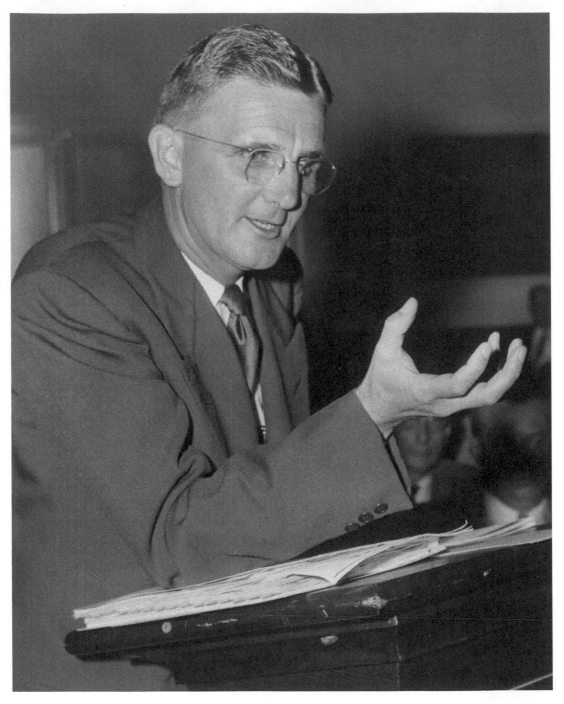

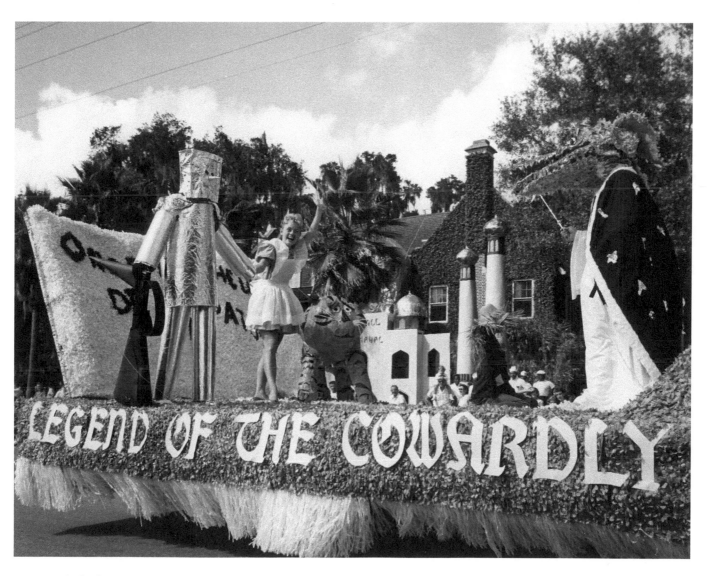

In 1924, the first University of Florida homecoming included a parade, which began on campus, headed downtown and around the courthouse square, and ended up back on campus. In this float from 1959, football boosters poke fun at a cowardly tiger. The LSU Tigers, UF's homecoming game opponents that year, were ranked number one nationally before the contest. A display of courage by both teams would fail to change the ranking. The Tigers won 9-0.

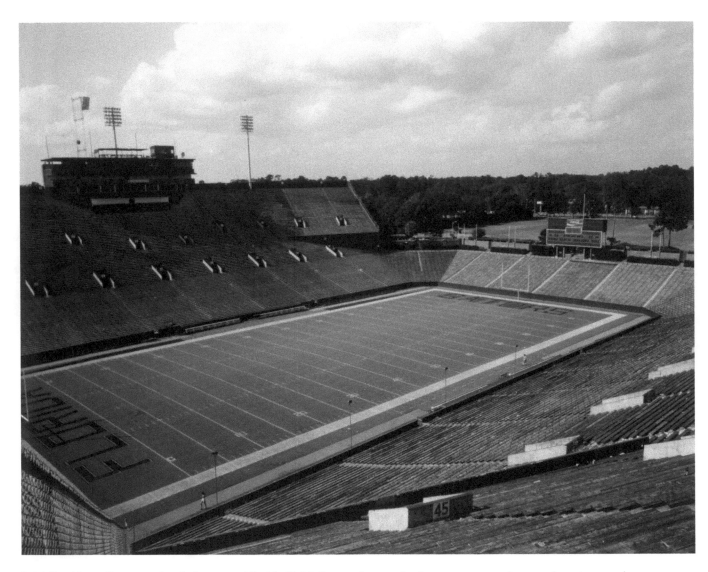

Initially, this stadium was simply known as Florida Field. Renovations and enlargements over the years have increased its capacity to more than 90,000. To recognize the financial contributions of leading university benefactor, the stadium is officially known as Ben Hill Griffin Stadium at Florida Field. Gator fans themselves refer to the venue as the Swamp, where the home team generally wins.

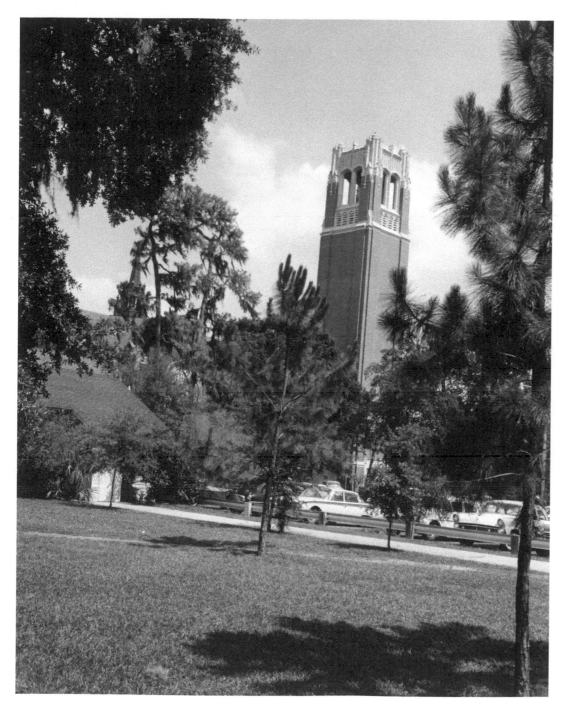

The Century Tower was erected to honor the university's students and alumni who were killed during the world wars. It was completed in 1955 and housed the Milton and Ethel David Carillonic Bells, which were donated to the university by their children. Those bells were replaced in 1979 by the Century Tower Carillon, whose 49 bells range in size up to about 7,000 pounds.

Notes on the Photographs

These notes, listed by page number, attempt to include all aspects known of the photographs. Each of the photographs is identified by the page number, a title or description, photographer and collection, archive, and call or box number when applicable. Although every attempt was made to collect all data, in some cases complete data may have been unavailable due to the age and condition of some of the photographs and records.

Printed in the USA
CPSIA information can be obtained
at www.ICGtesting.com
JSHW072023140824
68134JS00042B/3751